IMAGES
of America

NORTHFIELD

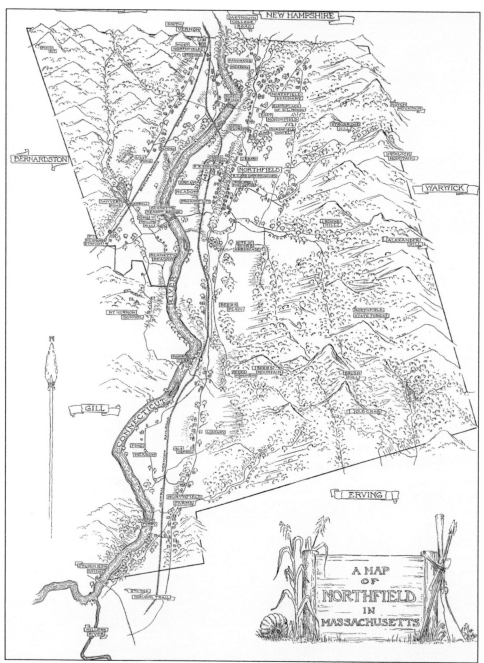

NORTHFIELD MAP. This early-20th-century map of Northfield, Massachusetts, includes features of the land and river, sites of historical significance, and the locations of railroad lines, ferries, bridges, schools, libraries, and churches. (Courtesy of Northfield Historical Society.)

ON THE COVER: This 1959 photograph of ice-skating on the pond at the Northfield Hotel/Inn captures memories of waltz tunes in the frosty air and the thrill of skating to music in the glorious setting of the inn. (Courtesy of Northfield Historical Society.)

IMAGES
of America

NORTHFIELD

Marie Booth Ferré, Susan Post Ross,
and Joan McRae Stoia

ARCADIA
PUBLISHING

Published by Arcadia Publishing
Charleston, South Carolina

Printed in the United States of America

Library of Congress Control Number: 2013957081

For all general information, please contact Arcadia Publishing:
Telephone 843-853-2070
Fax 843-853-0044
E-mail sales@arcadiapublishing.com
For customer service and orders:
Toll-Free 1-888-313-2665

Visit us on the Internet at www.arcadiapublishing.com

We dedicate this book to the families of Northfield, who will enjoy seeing images from their history; to the visitors to Northfield, who want to learn more about this historic town; and to the generations of the alumni who were educated in Northfield.

Contents

ACKNOWLEDGMENTS

Northfield is fortunate to have so many people who care deeply about its history, work to preserve its material culture, and are willing to share what they know. For the past year, many have supported our efforts and have been generous with their time and expertise. The organizations that provided most of the photographs and that maintain critically important collections are the Northfield Mount Hermon School (NMH) and the Northfield Historical Society (NHS). NMH archivist Peter Weis gave us access to the school's photograph collection, technical assistance, knowledge, and thoughtful guidance. Joel Fowler, president of the NHS, allowed us to mine the extensive collection of photographs throughout the summer, adding depth to our understanding of people and events. Fowler provided many answers to questions that arose in researching Northfield people, businesses, and farms. Edwin Finch shared his personal collection of photographs and memorabilia from both his childhood and his years as manager of the Northfield Inn and Chateau. Alexander Stewart brought the Moody Summer Conferences to life through recollections of his family's experiences. Joseph Graveline helped us to understand the Native American perspective. Peter Miller clarified the facts surrounding the railroad era. Jon McGowan and Tony Jewell's talks provided us with information for the transportation chapter. BNC-TV shared its local history videos with us. Groups and individuals lent photographs, and we credit them at the end of each caption. Finally, we wish to thank Debra Kern and the Dickinson Memorial Library for the care they have shown in creating the local history room, which we used often.

The extensive digital archives of the Library of Congress (LOC) and Wikimedia gave us access to some outstanding Northfield photographs. For information on homes, buildings, and historic sites, the Massachusetts Cultural Resource Information System (MACRIS), maintained by the Massachusetts Historical Commission, was a source of good background information and dates. Northfield's significance is greater than could ever be presented in this brief photographic survey. Therefore, we hope readers will view it as a spark for their own telling.

INTRODUCTION

For those who have little familiarity with Northfield, this book will introduce the dramatic story of one of the earliest English settlements on the frontier. The remote village of Squakheag, as Northfield was known, would eventually play a key role in the contest between England and France for control of the New World. For the many families with a long history here, the thousands of people who have been educated in Northfield, and still more who attended the Northfield Summer Conferences, the images gathered here will hopefully rekindle fond memories of those very special experiences. This book can be viewed as Northfield's scrapbook, a glimpse into the everyday life of the people who lived and visited here. This seems the best approach for a small volume containing selected highlights of the town's history from 1669 to the 1960s. Still, it is hoped that readers will linger long enough among the pictures to discover the recurring themes and values that help make Northfield unique.

The story begins with the Native people who planted, hunted, and fished in this area and revered the Connecticut River Valley for its abundant gifts. This book attempts to honor that reverence. Despite the fact that it took three attempts to settle the town and that few of the English dwellings survive, the original town plan is still very much in evidence in today's Northfield. The citizens' perseverance is to be admired.

Among people passing through contemporary Northfield, the most common reaction is "What a beautiful town!" If they know Northfield at all, they know about its impressive collection of imposing historic homes set back from the main street. Northfield center has remained relatively untouched since the early 1800s, a distinction the town owes to the Stearns family of artisans, whose work was as durable as it is beautiful. It is hoped that readers will be as delighted as the authors were to learn more about the inspiration that informed their aesthetic, the technologies that intrigued them, and what can only be described in modern terms as their intuitive marketing ability.

Of course, what goes on within a community is ultimately more important than its appearance. The vitality of Northfield's early-19th-century community is impressive. The archives of the Northfield Historical Society are full of programs and playbills from theatrical productions, lectures, dances, and other entertainments that took place with great frequency and enthusiasm. With prosperity came the appreciation and time for learning and self-improvement. The first Social Library was founded by a group of citizens in 1813. In the practice of law, Northfield was considered "a focus of legal talent" in the county, and it is credited with producing at least one Supreme Court justice.

In the mid-19th century, Northfield's economy was supported by farming and enriched by what is thought of today as a "clean industry"—education. While remaining largely uninvolved in the manufacturing activity that characterized other Massachusetts towns during the industrial revolution, Northfield was by no means unaffected by it. The town benefited significantly from several trends in the Victorian era.

First, Northfield's location in the heart of New England made it a hub for the new railroads crisscrossing the region. If a passenger was going anywhere in New England, they went through Northfield. Second, due to the educational and religious fervor of the times, the town became home to several academies, including the Northfield Seminary and Mount Hermon School for Boys, founded by native son D.L. Moody and his family. Through their efforts, Northfield became an internationally known center for missionary training and Protestant thought. Moody brought vision to the list of Northfield values.

Lastly, since manufacturing was a dirty activity, city dwellers found it necessary to retreat to the countryside during the summers to escape the smoke and smell. Northfield's picturesque hills, clean air, ponds and streams, and rail service made it a popular destination for those seeking relief from the cities. A grand hotel, the Northfield, with an array of amenities like golf, tennis, swimming, and ice-skating, drew wealthy tourists, celebrities, and politicians to town. Today's tourists and recent arrivals will be surprised by the descriptions of the retail and service businesses that sprang up in response to religious and recreational tourism, only a fraction of which appear in this book. These merchants exhibited ingenuity.

In addition to its physical attributes, one of Northfield's strengths, less visible on the surface but nonetheless ever-present among its people, is its spirit. That spirit was tested during the 20th century, when the town experienced two punishing floods and the 1938 hurricane. While the river has been a source of sustenance, it also took a huge toll on the town. The devastating effects on the community from fires and natural disasters are evident in the photographic record, reminding citizens how the work of generations can be washed away in a few hours. After the disasters, Northfield's people responded by forming clubs, building new public schools, and coming together to celebrate important historical milestones with parades, festivals, and pageants. Add to Northfield's list of attributes, then, resilience and determination.

The purpose of this book is not merely to glorify the past, but to use it as a tool for envisioning what lies ahead. Today, Northfield is once again in transition. The lesson of these photographs is that change is a natural and recurring process. What emerges from the closing of one era builds on the past while developing its own defining characteristics. The best of what was is still here.

One indicator of that is a resurgence of interest in agriculture. Organic farming, biomass, small-scale production, heritage fruits, and farm-to-table cuisine (what the old-time farmers would call "eating well") are diversifying Northfield agriculture. Once again, the beautiful landscape beckons to urban dwellers as strongly as it did in Moody's time, offering a refreshing respite from urban congestion and life's complications. It is hoped that, in perusing these pages, visually strolling along Main Street, readers will agree with the many visitors who say that being in Northfield is like stepping back into a more romantic time.

Dedicated Northfield citizens are helping to recreate an outdoor recreation identity for the town. New state forests, improved mountain trails, updated athletic facilities, and clean waterways are ready for thousands of visitors as a result of these efforts. The Schell Bridge is slated to become a bikeway, and even the trains are returning after 60 years!

Finally, the vacant Moody campus will hopefully attract a vital educational institution to town, filling a void, bringing new academic and community traditions, and creating more of the necessary conditions for economic growth.

Reverence for the land, perseverance, innovation, vision, industry, and resilience are the hallmarks of this community. It is hoped that readers will see them in the following pages and experience them the next time they explore Northfield.

—Susan Post Ross
Joan McRae Stoia
Marie Booth Ferré
Northfield, 2014

One

Tip of the Spear

Squakheag

THE STORY. In 1669, 300 years before this stone was set, four Englishmen discovered land for the northernmost English settlement in the colony. Scouting for the governor, they followed the Quaboag Indian trail over "Old Crag" and viewed the Great River, with a fertile plain and lush broad meadows being cultivated by a native population. They spoke with the Squakheags and exchanged gifts. Native Americans, who revered the land for use by all, did not grasp the full meaning of property ownership, but in 1671, Squakheag was deeded to the English, and the struggle to create an English town began. (Courtesy of Daderot/Wikimedia Commons/Public Domain.)

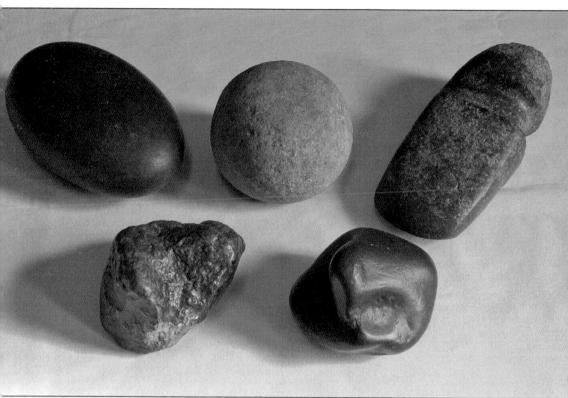

SQUAKHEAG. For 1,500 years before the English arrived in Northfield, natives farmed and fished the Quinnetucket (later known as Connecticut) River. Later, residents searching along Northfield's streams and fields found primitive stone tools of Native Americans. Shown in this photograph are, clockwise from the top left, a birthing stone, its rich patina showing evidence of long use during labor; a game ball; a woodworking tool; and two dove-shaped stones used for grinding corn found at the site of the Squakheag stockade. During the warmer seasons, Squakheags and other visitors lived in villages along cool tributary streams. Natives arrived when the shadbush bloomed, fished for shad and salmon, and planted corn in Squakheag fields. As fall approached, they dried fish and corn for winter storage and had harvest celebrations. During winter, they moved on to hunt for deer, bear, and other animals. During the 1600s, illnesses like plague and smallpox carried by European river traders had decimated the native population. When the Squakheags deeded their land to the English in 1671, few remained. (Photograph by Carol Pike, courtesy of Nolumbeka Project and Dickinson Memorial Library.)

FIRST SETTLEMENT. In 1673, with permission of the General Court, 16 English claims were established along a main street laid out at Squakheag. In the English style, these were deep and narrow lots for future homes and farms. Settlers' primitive, thatch-roofed dwellings were built close together inside a stockade at the south end of the street, on the site of the original Squakheag palisade. A share of the meadowland by the river was given to each stockholder in the claim, with the share's size corresponding to the amount of the stockholder's investment. (Courtesy of M. Ferré.)

HERE, ENCLOSED BY A STOCKADE, THE FIRST SETTLEMENT OF THIS TOWN WAS MADE IN 1673.

NINE RODS WEST, A FORT WAS BUILT IN 1685; REBUILT IN 1722.

EIGHT RODS SOUTH EAST STOOD COUNCIL ROCK

HERE UNDER A LARGE OAK, STANDING UNTIL 1869, THE FIRST PUBLIC RELIGIOUS SERVICES IN THIS TOWN WERE HELD IN 1673.

OAK TREE MARKER. Without a meetinghouse, Elder William Janes, the community's religious leader, gathered the settlers together for their first Sabbath beneath the branches of a nearby oak tree. A devout and learned man, Janes was said to have called upon the Old Testament story of the "Promised Land" during these early months at Squakheag. (Courtesy of NHS.)

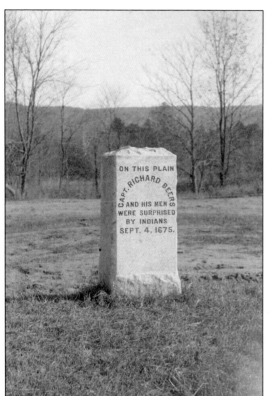

KING PHILIP'S WAR AND BEERS PLAIN.
When Wampanoag sachem King Philip's campaign against the English settlements spread into Western New England in 1675, the town was garrisoned in the stockade, with Samuel Wright in command. When natives attacked, Wright perished defending the stockade, leaving a wife and seven children and the other families trapped. Everything outside the stockade was destroyed: houses, cattle, and fields of grain. Capt. Richard Beers's relief party, sent from Hadley, was ambushed several miles south of the stockade. Beers and 21 of his men were killed. The English abandoned Squakheag. King Philip and his men commandeered a bluff above the river during the winter of 1675–1676, as marked below. The Beers monument, pictured left, is on Millers Falls Road, south of the village. (Left, courtesy of NHS; below, S. Ross.)

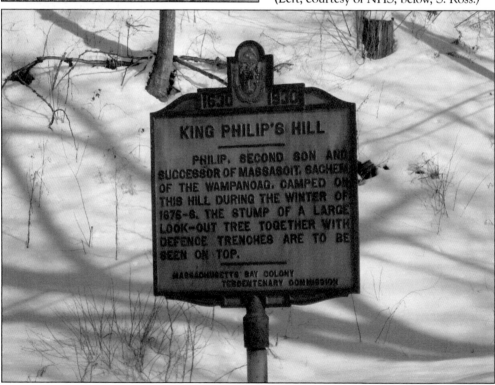

SECOND ATTEMPT AT SETTLEMENT. The original claimants were allowed to rebuild in 1685. Forts were constructed at the north and south ends of Main Street, and a burying ground was established where Wright fell during the earlier attack. Squakheag became Northfield, the northernmost English outpost and defense against French expansion, or "the tip of the spear." (Courtesy of S. Ross.)

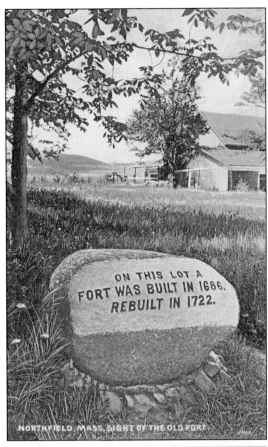

CLARY'S MILL. The new settlement needed a grain mill, and John Clary Jr., an experienced miller from Hadley, was offered 20 acres of land if he would set up a gristmill on Mill Brook. He established his family in Northfield and set up a mill, but on August 16, 1688, John Clary and his 15-year old daughter were killed by natives. Abandonment of the second settlement became inevitable. (Courtesy of Daderot/ Wikimedia Commons/Public Domain.)

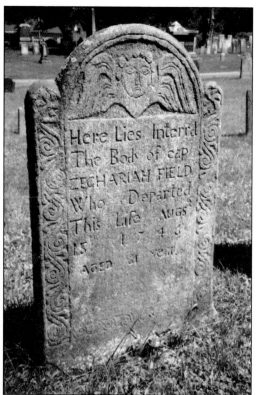

CENTER CEMETERY. Sarah Mattoon, a girl whose family had fled Northfield in 1675, was captured and carried away by natives in the 1704 attack on Deerfield. She was redeemed by young Zechariah Field of Northfield. The couple married, returned to Northfield, and built a home at Main and Maple Streets. There are 80 Mattoon and 150 Field known gravesites in the Center Cemetery. Field's stone (shown) was probably carved by Jonathan Hartshorne. The stones in Center Cemetery constitute the earliest form of European sculpture in the Americas. (Courtesy of M. Ferré.)

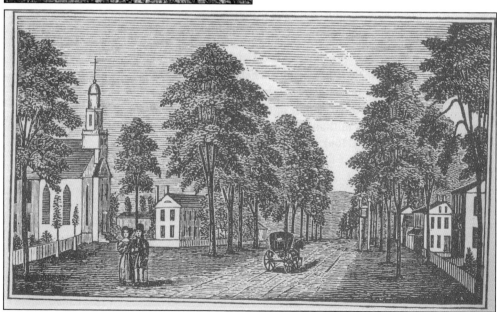

FINALLY SETTLED. Queen Anne's War between the French and English ended in 1713, opening a period of stability. Survivors of Northfield's first two settlements were allowed to return in 1714 to establish the third and final settlement, provided they hired a suitable minister. Rev. Benjamin Doolittle arrived in 1718, serving until his death in 1749. The first meetinghouse was located in the middle of Main Street, long before the meetinghouse on the left was built by 1767.

Two

Northfield Architecture
The Stearns Family

Northfield Common, 1893. Northfield possesses a spectacular collection of 19th-century homes created by the Stearns family of architect-builders between 1805 and 1899. Calvin Stearns worked in Boston for prominent architect Asher Benjamin. He incorporated the Federal style of the young republic into homes in his native Northfield, giving Main Street its elegant style. Shown here is the building known locally as the "Beehive" (left)—an early town tavern and, later, an academy for students bound for higher education—as well as the linear town common. (Courtesy of Dickinson Memorial Library.)

CALVIN STEARNS RESIDENCE. Stearns learned design as a journeyman carpenter on diverse projects in Vermont and Massachusetts. As yet unmarried, he defied convention by building a house for himself on Maple Street between 1805 and 1808, revealing his craftsmanship to prospective customers passing by. "Modern" elements included a hipped roof and semicircular fanlight over the door. In 1807, he brought his wife, Statyra, to Northfield, where they had 10 children. (Courtesy of NHS.)

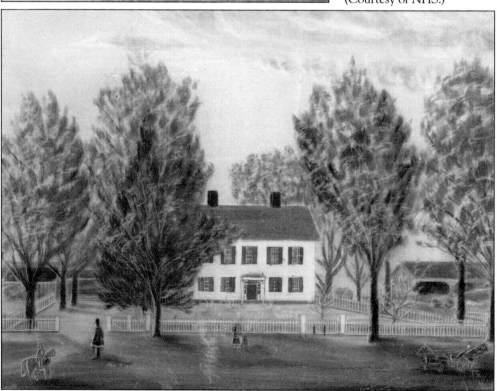

THE NEVERS HOUSE, 1850. Calvin Stearns' first commission was in 1811 from Gen. John Nevers, an influential lawyer and elected official. The cantilevered staircase, quarter fans, and scrolled dental work on the gable ends of the Neoclassical Main Street home demonstrate the shift from purely functional dwellings to representations of status. The scroll motif is repeated in Nevers's law office off the south entrance. The busy street scene comes from an original 1850 drawing. (Courtesy of S. Stoia.)

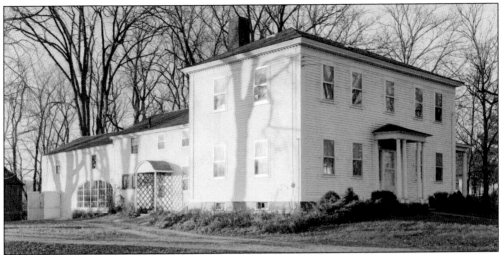

ISAAC MATTOON HOUSE. Stearns included features in this 1816 house that he later employed on later projects and that were copied by other homeowners. The double-columned portico signaled Mattoon's prominence in the community, and the technologically challenging hipped roof contributed Georgian influences to the Neoclassical building. An ell placed at the center of the back wall provided a warm southern exposure for domestic work, away from formal activities in the front parlors. (Courtesy of LOC.)

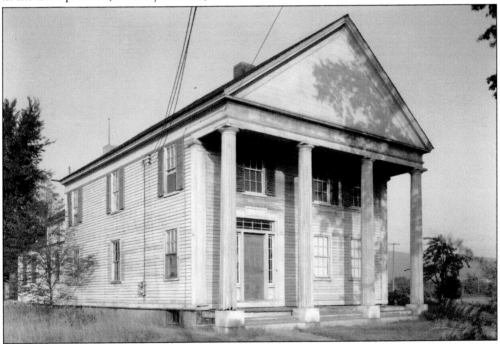

ELIJAH BELDING HOUSE. This 1840 home in West Northfield features a Grecian-style columned portico popular at that time. By 1840, Calvin's sons Charles and Albert and his son-in-law Harvey Field were doing the heavier work for the older man. Having fabricated the columns on the Murdock house on Main Street that same year, Field may have constructed those on the Belding House, using a technique that has preserved Stearns-built columns from deterioration. (Courtesy of LOC.)

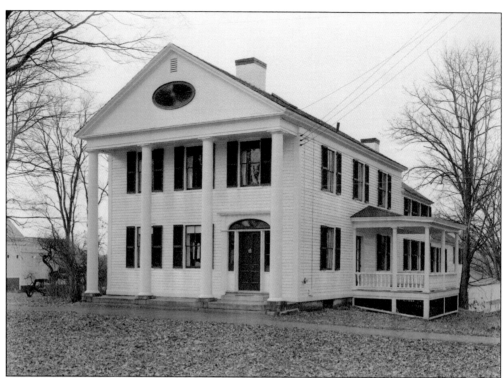

SAMUEL STEARNS HOUSE. In the 1820s, the Stearnses' work had a profound influence on home design, especially Samuel Stearns's own house, built between 1819 and 1825, which scholars contend changed the course of Northfield architecture. Located prominently on Main Street, on land formerly owned by Ebenezer Field, Samuel's house was larger relative to family size and had a temple front, urban-styled basement kitchen, and internal gutters. The most innovative and influential component was Calvin's dramatic curved staircase in the main hall. An entrance on the south side reflects a greater emphasis on the domestic life, as opposed to formal front entrances previously reserved for visitors. The north porch was added later. (Both, courtesy of LOC.)

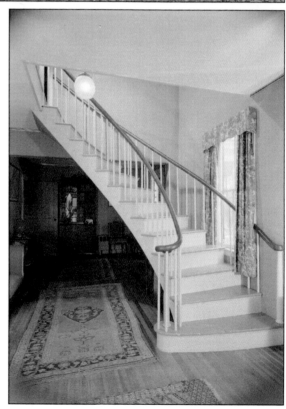

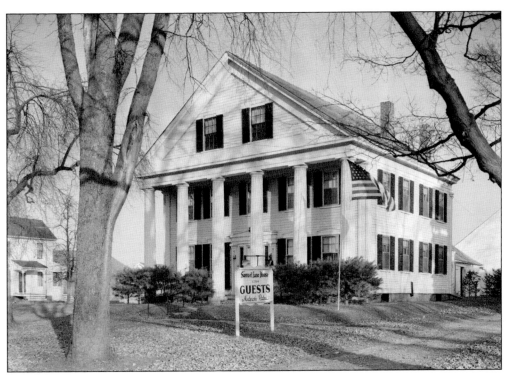

SAMUEL AND CHARLOTTE LANE HOUSE.
Calvin's designs were so innovative
that his sons could work in the same
vernacular, adding embellishments in
their own era. George Stearns built
this mansion in 1845–1846 for his sister
Charlotte and Samuel Lane, a wealthy
whaling captain. The high pediment,
portico, and massive columns make
the house seem larger than previous
Stearns mansions. Charlotte took in
boarders during her husband's long sea
voyages. Future owners hosted tourists
in later years. (Courtesy of LOC.)

DANIEL CALLENDER HOUSE. The Stearns
family members' own homes demonstrated
new building features and set style
standards for the town. In commissioning
George Stearns to build his house at
the south end of Main Street, Daniel
Callender wanted the front of the 1846
building modeled on the other temple
front homes on Main Street. (Courtesy
of MACRIS.)

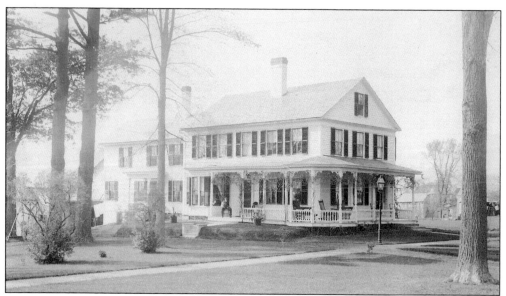

JAMES MATTOON HOUSE. Calvin Stearns built this 1829 house over a three-year period for Isaac Mattoon's son James and his wife. It was a simplified version of the Samuel Stearns house, with a side entrance but without the columns. In later years, the porch was extended around to the side, and bay windows were added. (Courtesy of NHS.)

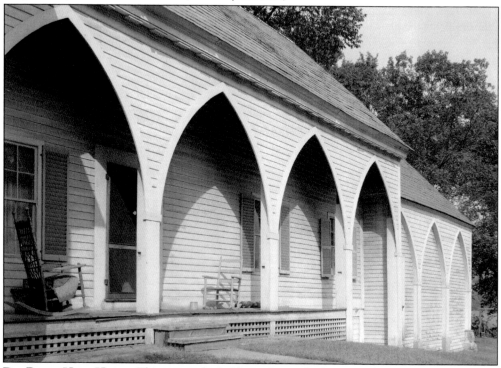

DR. PHILIP HALL HOUSE. This one-and-a-half story home, built in 1846 by the Stearns brothers, is considered one of the best examples of Gothic Revival architecture in the area, combining Greek columns with Gothic arches. The overhang on the south porch reflects mid-19th-century interest in medieval design, adopted widely in rural settings. (Courtesy of LOC.)

Three

STEWARDS OF THE SOIL
EARLY FARM LIFE

WEST NORTHFIELD, 1890. For centuries, the rich alluvial soils along the Connecticut River provided native inhabitants with resources to sustain themselves. In the 19th century, Northfield farms and farm-related businesses provided the townspeople with a prosperous agricultural economy. Farmers along both sides of the Connecticut River used the broad meadows to grow corn, tobacco, broomcorn, hops, and other crops. In the uplands, apple orchards bore fruit in abundance for cider. Flocks of sheep filled the hillsides. Dairy farms raised prized cows and sold milk and cream to the residents. (Courtesy of NMH.)

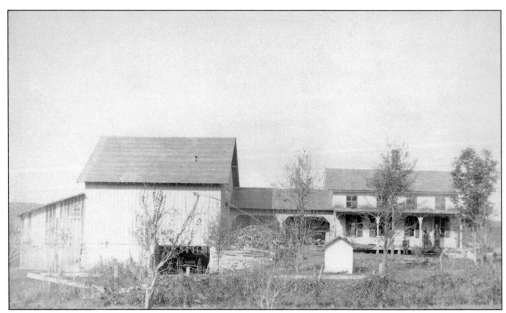

PARKER FAMILY HOME, 1890. Henry B. and Hannah Caldwell Parker had moved to Northfield in the 1860s and settled on Munn's Ferry Road. They had several successful businesses nearby along Merriam Brook. Travelers would pass this house if they wanted to take Munn's Ferry to Gill. (Courtesy of NHS.)

PARKER'S SASH AND BLIND MILL, 1890. Built in 1835, Henry Parker bought this mill in 1860 and manufactured blinds, sash, house trim, brackets, and moldings for homes in the Northfield area until 1898. In addition to manufacturing house-building products, Parker made tobacco boxes and used the mill's waterpower to press apples into cider. (Courtesy of NHS.)

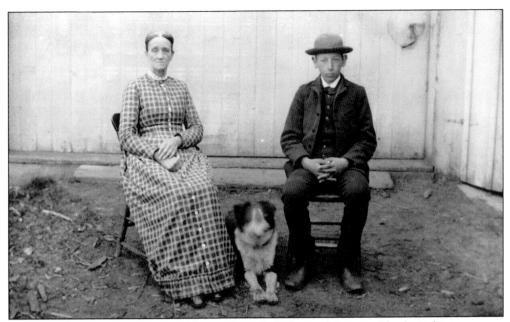

HANNAH AND CHARLES PARKER. This is Hannah Parker and her son Charles, who appears to be about 14. He would be expected to do as much farmwork as an adult. Charles probably would have also been expected to work in the family's sash and blind mill. (Courtesy of NHS.)

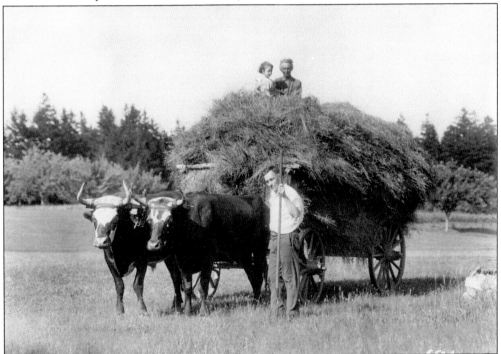

MAKING HAY. Hay for Northfield cattle and horses was harvested in June, and again later in the summer. This child and her grandparent ride atop a hay wagon brimming with sweet fresh hay, on its way to be stored for the winter. This photograph was taken between 1900 and 1920. (Courtesy of LOC.)

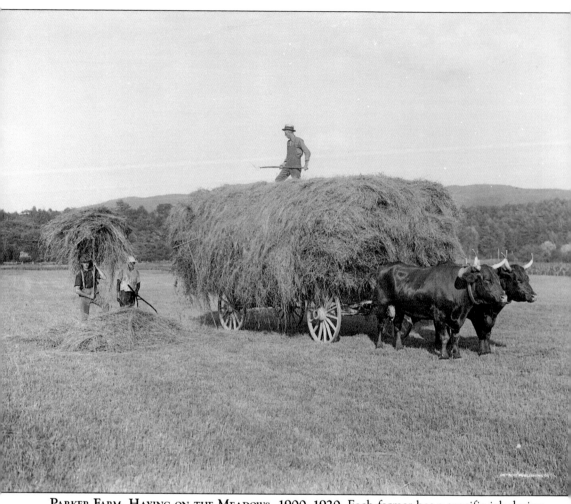

PARKER FARM, HAYING ON THE MEADOWS, 1900–1920. Each farmer has a specific job during haying. One man wields a scythe, while another rakes and pushes the hay up to the farmer with the pitchfork on the top, who must also keep an eye on the team of oxen. Many farm tools were made locally, and Webster's General Store sold farm implements until new retail businesses emerged. Oxen were the best draft animals and cost about half as much as horses and required much less feed. As a bonus, they could be eaten when they died. Oxen did not move as fast as horses, and as farm equipment changed, oxen seemed physiologically unsuitable for pulling the newer machinery. Advances in agricultural technology eventually led to the emergence of the draft horse as a farmer's principal work animal. (Courtesy of LOC.)

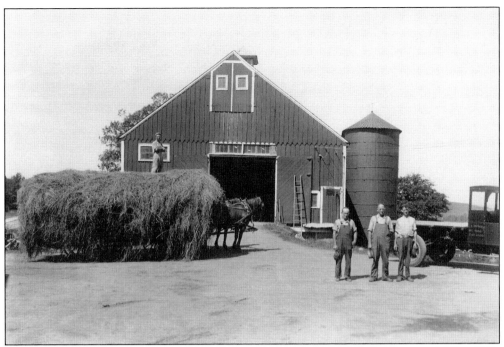

RIVERVIEW FARM, 1930. Henry and Hannah's son Charles Parker had a farm on Millers Falls Road. Here, Eugene Williams stands on the hay wagon as the driver of the horses. Charles stands between Ernest Parker (left) and Happy Moon. (Courtesy of NHS.)

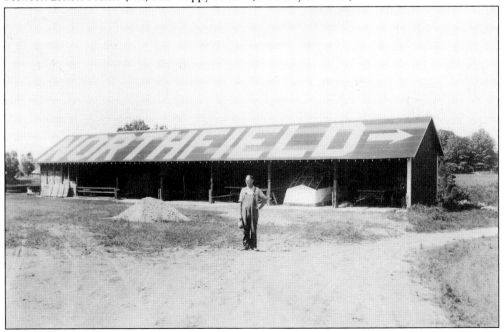

PARKER FARM SHED, 1930. Looking at the horse-drawn hay wagon in the previous image, one might wonder just how mechanized the Parker farm was in 1930. Here, Charles stands in front of his equipment shed. The "Northfield" sign on the roof was an example of "air marking," for the benefit of passing pilots. (Courtesy of NHS.)

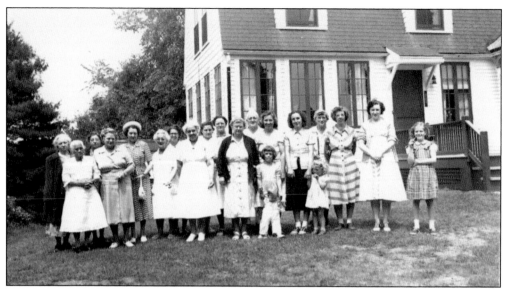

LADIES BENEVOLENT SOCIETY SUMMER PICNIC, 1950. The Ladies Benevolent Society, a Northfield Farms organization, was incorporated in 1893 for the purpose of establishing and maintaining a library and place for social gatherings. In 1970, the society became the owner of No. 4 Schoolhouse, which it had used for many years. The picnic was held annually at a home near the river. (Courtesy of J. Fowler.)

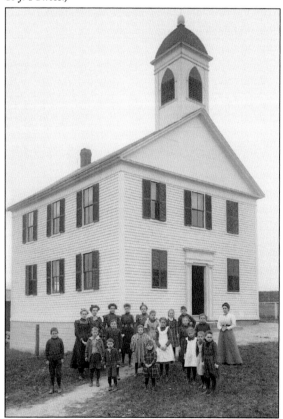

NO. 4 SCHOOLHOUSE, c. 1900s. Built by the Stearns in 1841 on land donated by the Gilbert family and with funds donated by residents of Northfield Farms, this building served not only as a school for neighborhood children, but also as a place to hold religious meetings, Sunday school classes, and meetings of neighborhood organizations, such as the Ladies Benevolent Society. During the 1936 flood, 50 people displaced by the disaster took shelter here. The Northfield Farms Community Club was formed in 1928 for the welfare of the community and to ensure the maintenance of this building. The schoolhouse is now privately owned. (Courtesy of J. Fowler.)

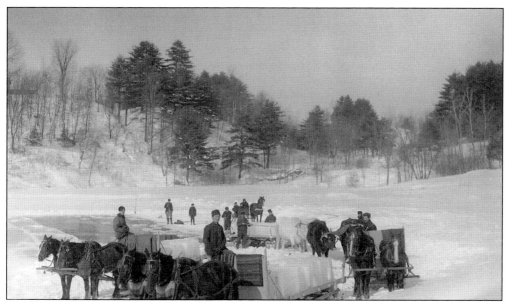

SAVING WINTER ICE, 1890S. During the frigid days of winter at the turn of the century, farmers harnessed their oxen and horses to harvest ice. They cut blocks of ice from frozen ponds, and, as shown here, at Wanamaker Lake. After the horses made the large cuts, the blocks were cut by hand, packed in sawdust, and stored in icehouses until the summer months. Many Northfield ponds were harvested to keep iceboxes cold and milk cool in the warmer months and to provide the ultimate summer treat: ice cream. (Courtesy of NMH.)

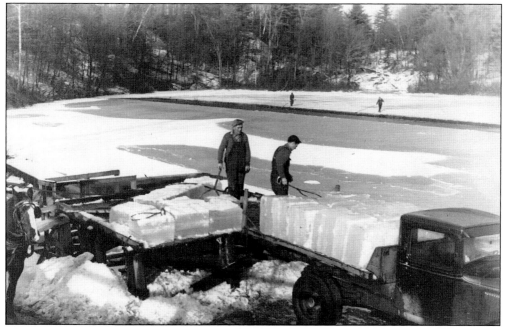

WANAMAKER LAKE ICE HARVEST, 1920S. Eventually, ice harvesting became more mechanized. Horses were employed for brute strength and cutting, but trucks carted the ice away. One inventive farmer, Ralph O. Leach, developed a motorized ice-cutting device that was said to have been able to cut as many as 1,000 blocks a day. (Courtesy of NMH.)

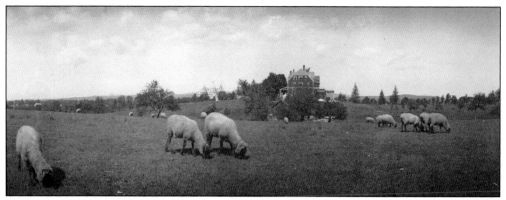

COUNTING SHEEP, 1910. At one time, in the late 18th century, over 2,000 sheep were raised on farms in Northfield. A century later, in the early years of the Northfield Hotel, there were still flocks of sheep grazing on the grounds of the hotel. Wool was still in demand, and lamb was on the hotel menu. (Courtesy of NMH.)

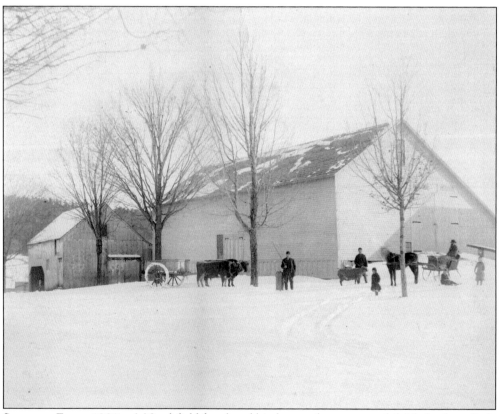

SEMINARY FARM, 1890s. A Northfield farmhand hitches up the oxcart and sleigh for three little girls and their grandfather. The sleigh is the best way to ride over unplowed snowy roads. The sheep will keep the children warm in the cart. (Courtesy of NHS.)

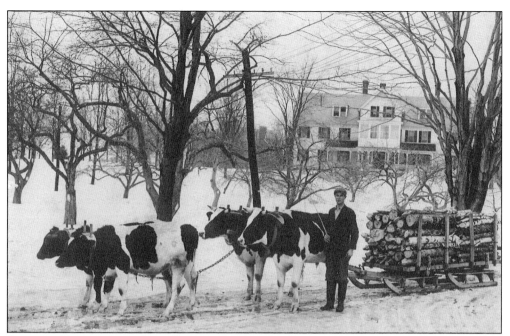

SEMINARY FARM, 1918. When all the corn was in the silo, winter was the best time to cut wood. It could be more easily transported with a sled. This young farmhand and two pairs of yoked cattle make their way along Winchester Road on the edge of the seminary campus with a very heavy load. (Courtesy of NMH.)

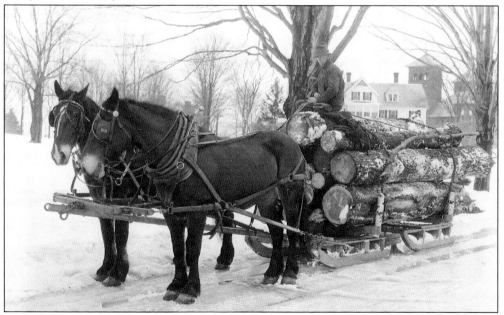

WINTER LOGGING, 1926. Northfield Seminary horses pull a heavy sled, possibly headed for the Northfield Hotel, owned by the Northfield Schools. It took a large work crew to keep the seminary, Mount Hermon, and the auxiliary enterprises running smoothly. The seminary and Northfield Hotel/Inn employed many local men to work on the farm, the grounds, the heating plants, and more. (Courtesy of NMH.)

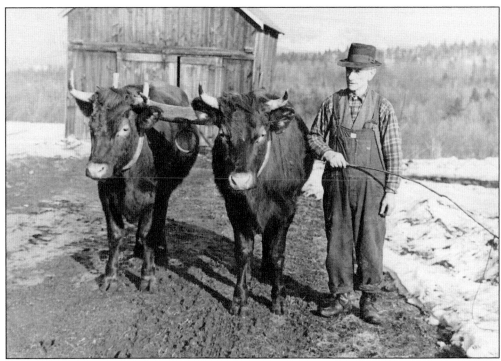

New England Farmer. In an agricultural community, there was no retirement. In this photograph, the receding snow on the ground, the man's flannel shirt with just an extra vest, the high boots, and a certain quality of light all suggest that it is almost mud season. This Northfield farmer and his oxen are ready for spring. (Courtesy of NHS.)

A Farm School. For many years, Northfield Seminary provided all the milk for the seminary girls and for the families who lived in the neighborhood. An impressive number of pedigreed cows grazed in the pastures, corn for winter silage grew in the fields, and the farm provided employment for local people. In 1961, the entire dairy herd, from both seminary and Mount Hermon, was sold, and the farm program was moved to Mount Hermon. The beautiful barns remain to honor the past. (Courtesy of MACRIS.)

Four

VILLAGE LIFE
COMMERCE, EDUCATION,
AND CELEBRATIONS

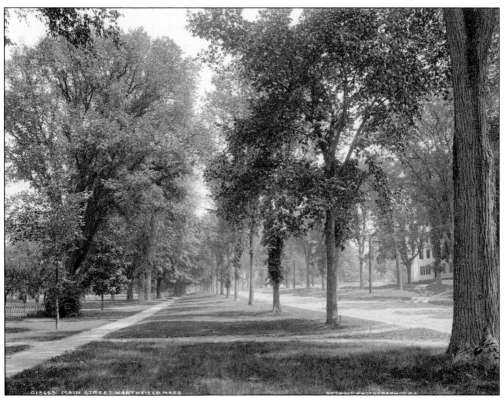

NORTHFIELD'S MAIN STREET, 1893. Main Street was laid out two miles long and 165 feet wide. Between 1812 and 1815, four rows of maple and elm trees were planted the length of the linear common. The building on the right was erected as Hunt's Tavern in 1765. It still stands as one of Northfield's oldest buildings. The tavern was a way station on the road to Boston that went by Notch Mountain and through Warwick. (Courtesy of NMH.)

THE NORTHFIELD ACADEMY OF USEFUL KNOWLEDGE. Opened as a school for boys in October 1829 in the former Hunt's Tavern, this academy stood next door to the Center School. It remained open for only 13 years. Being a place of busy learners, it acquired its name, "the Beehive." At a time when many boys received no more than an eighth-grade education, the academy's purpose was to bridge the gap between grade school and college. At the time of this photograph, the building was Bronson's Inn and Bronson's Nursing Home. (Courtesy of NHS.)

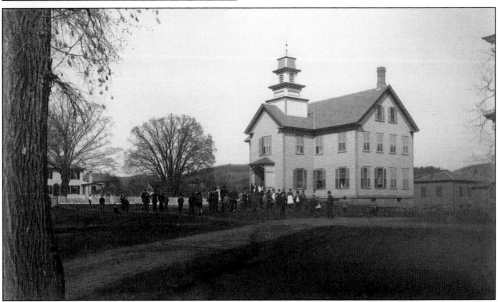

NORTHFIELD CENTER SCHOOL, 1890S. In 1836, the town voted for funds to construct a school in the road just north of Hunt's Tavern. Seth Field was schoolmaster for almost 30 years. Because children walked to school, eventually, more schools were built in various neighborhoods as the town grew. This schoolhouse was destroyed by fire in 1940, and classes were held in the town hall and high school until today's Northfield Elementary School opened a few years later. (Courtesy of LOC.)

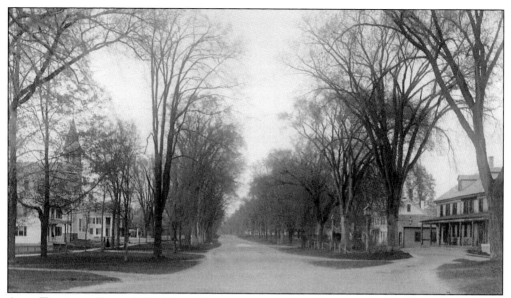

AMID TOWERING ELMS, 1893. Horse-drawn stages traveling the turnpike from Boston and points east came over the mountain, skirting the "Great Swamp." Upon entering Northfield, they pulled into the driveway on the right for food and lodging at Houghton's. Several Stearns-built homes are seen here. St. Patrick's Catholic Church (left) opened its doors in December 1886 with an organ donated by D.L. Moody. (Courtesy of NMH.)

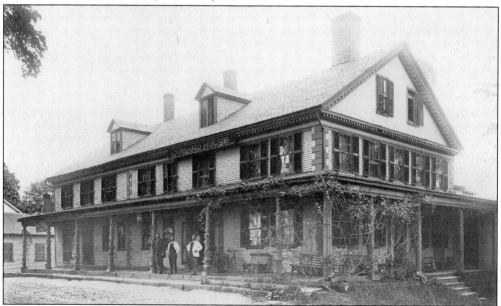

HOUGHTON'S TAVERN/LOVELAND HOUSE, 1890s. In 1799, the General Court created a turnpike to Boston that ended at Houghton's Tavern, located at the corner of Main Street and Turnpike Road (Warwick Road). Hunt's Tavern had a competitor, and Houghton's quickly became the center of social gatherings and a political headquarters. The Social Library, a precursor to Dickinson Memorial Library, was housed here. Before it burned to the ground in 1903, Houghton's Tavern had a number of new names and innkeepers, including one who called it Loveland House. (Courtesy of NHS.)

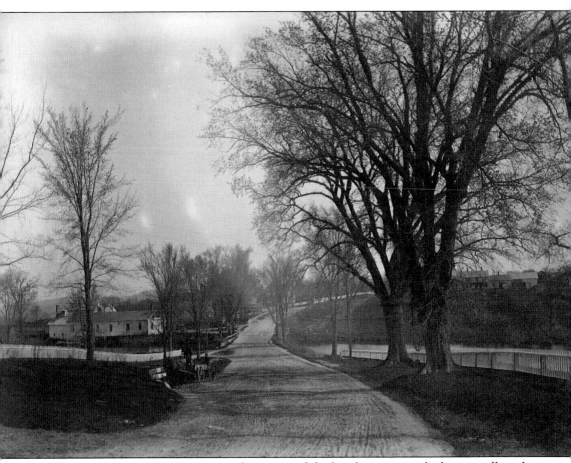

WEBSTER PONDS, 1893. Businesses along most of the brooks in town relied upon millponds to store water and waterwheels to power the mills. Maps of early Northfield show millponds on every stream leading to the Connecticut River. The Webster Ponds were on either side of the Mill Brook Bridge on Main Street heading into East Northfield. Between Main Street and the river, Mill Brook has a steep descent, creating ideal conditions for setting up ponds to harness waterpower. Mill Street and Glen Road had much business activity related to the agricultural economy. Early in the second settlement of Northfield, John Clary set up a gristmill on Mill Brook. In the late 19th century, just downstream from the Henry W. Webster gristmill, the Herbert Austin Reed sawmill was powered by a waterwheel with its own dam. At that time, Glen Road went all the way to the Connecticut River, where carts could cross over the river below the train tracks on the railroad bridge. (Courtesy of NMH.)

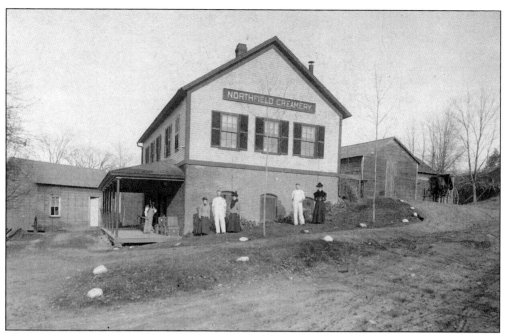

THE COOPERATIVE CREAMERY, 1890S. To provide a profitable outlet for dairy farmers, The Cooperative Creamery was incorporated in 1885. The stockholders were mostly patrons. Located along Mill Brook on Glen Road, farms provided milk, and local patrons purchased butter. To make this possible, they needed milk from 600 cows daily to make 400 pounds of butter. (Courtesy of NHS.)

J.T. CUMMINGS CARRIAGE AND SIGN PAINTING, 1890S. It would not be long before businesses like this would be replaced by a series of automobile service stations on the corner of the Old Warwick Road (presently School Street) and Main Street. J.T. Cummings serviced the needs of cart and carriage owners and kept carriages looking new. (Courtesy of NHS.)

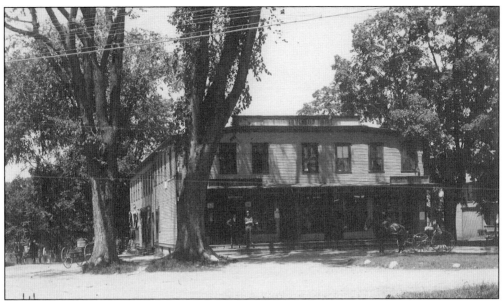

The Webster Block. C. Hastings owned a general store on this site, but it burned down in 1879. It was rebuilt shortly before the turn of the century by Charles H. Webster. The structure housed a pharmacy, a post office, and a food store for farmers coming into town and residents of Main Street. (Courtesy of NMH.)

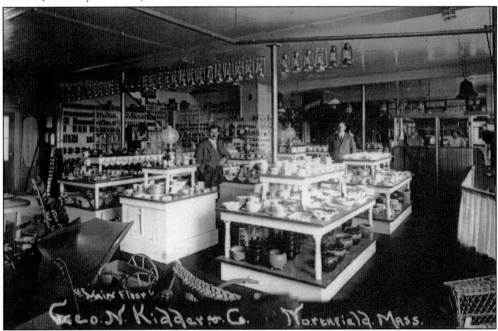

Kidders, 1900s. The George N. Kidder Company opened its doors in 1901 in response to the needs of residents for household items and home furnishings for the many new homes and summer cottages in town. These items were not made in Northfield but mass-produced in new factories by workers in cities throughout New England. Electric lighting was available, as well as a generous supply of kerosene lanterns. This early store was in the back part of the Webster Block. (Courtesy of NHS.)

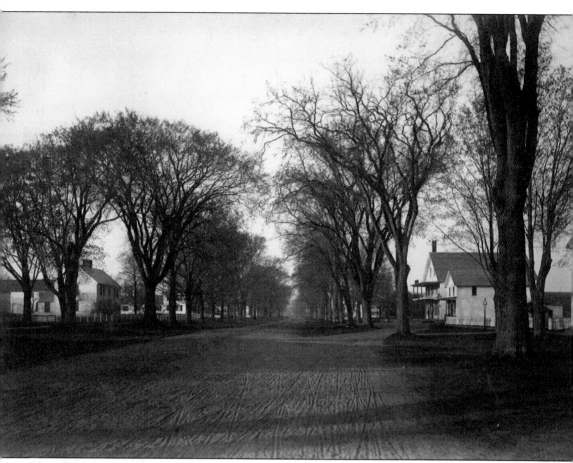

View South from the Town Center, 1893. This photograph presents a view of Main Street when there were few telephone poles. Electric poles were not erected until 1909–1910. The large building on the right with a second-story porch was the Charles E. Williams General Store. The small building on the right has housed a laundry, a plumbing shop, a tailor shop, and an ice cream stand The first home on the left is the Reuben Wright house, built in 1750. It is one of the oldest houses on Main Street. The house remained in the Wright family for many years. Their home lot was deep and provided acreage to farm. Most homes were fenced to keep animals from wandering into the road. Beginning in 1902, the very dusty road was improved with the laying of a macadam surface. (Courtesy of NMH.)

C.E. WILLIAMS STORE, 1902. The building shown above was constructed by Joseph Williams for his son "Chub," who was returning to Northfield after working as an S.S. Pierce salesman in Boston. While some residents of Main Street walked to this store, many homes in Northfield used the C.E. Williams delivery service provided by horse and wagon (below). Like today, the porch invites townspeople to stop and talk about the latest news. In 1902, these men might have been talking about Pres. Teddy Roosevelt coming to town or about Francis Robert Schell's extravagant chateau being built on the northern end of town. Later in the century, the Williams store became an A&P grocery store for a short time before washing machines and dryers were installed for a laundromat. (Both, courtesy of Dickinson Memorial Library.)

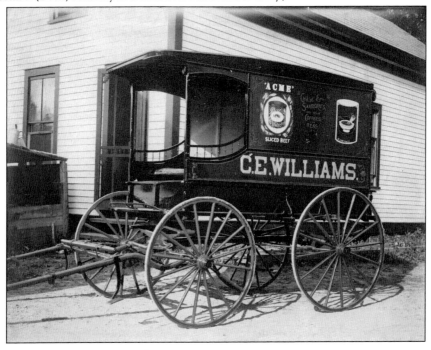

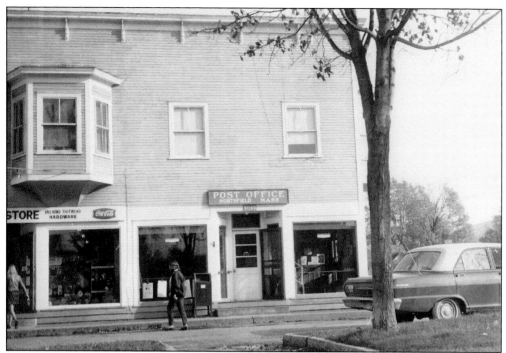

PROCTOR BLOCK. In 1898, Arthur W. Proctor built Proctor Block on the site of Houghton's Tavern. The Proctor Variety Store was a big business with five clerks and two delivery wagons working throughout the week to meet the demands of year-round and summer residents. Along with numerous small businesses housed here over the years, C.C. Stearns sold clothing and Avery's Variety Store for decades served as Northfield's general store. (Courtesy of NHS.)

NORTHFIELD FIRE STATION, 1940s. During Northfield's first two centuries, when bucket brigades were the accepted method for putting out house fires, many fine homes were lost. In 1901, the town voted to buy a hose cart for the volunteer fire department. In the mid-1920s, the town purchased Engine No. 1 and about 15 years later purchased Engine No. 2. These were housed in the fire station next to the town hall until the current fire station was built in 1953. (Courtesy of NHS.)

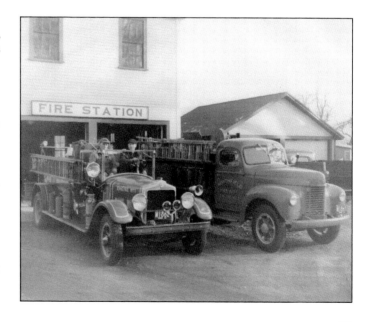

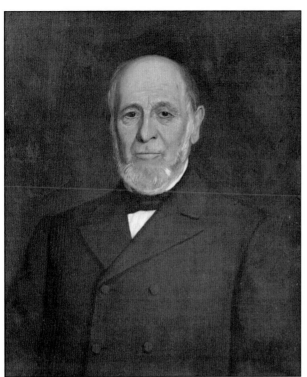

ELIJAH DICKINSON, 1890s.
A descendant of Nathaniel Dickinson, an early Northfield settler killed on Pauchaug Hill, where a marker stands today, Elijah was born in West Northfield and became a successful Fitchburg manufacturer. In 1896, Dickinson decided to give funds for a Northfield library in memory of his ancestors. The building, designed for Main Street, was constructed of granite from the Northfield Mountain quarry. (Courtesy of NHS.)

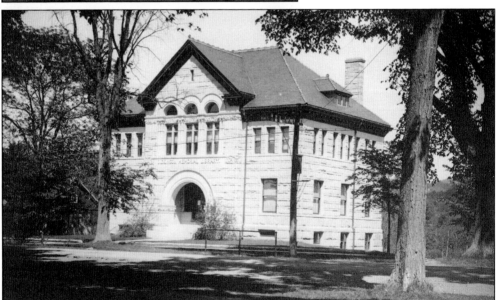

DICKINSON MEMORIAL LIBRARY. Dedicated on June 9, 1898, the Dickinson Memorial Library replaced the Social Library first maintained at Houghton's Tavern. The new library provided the townspeople with opportunities for lifelong education. It not only lent books, but until recently, it also had a museum of artifacts, historical exhibits, and interesting objects from nature. The top floor was used for community functions, including dances. For many years, Dickinson Memorial Library served all the schoolchildren before schools had their own libraries. This photograph was taken sometime between 1900 and 1920. (Courtesy of NMH.)

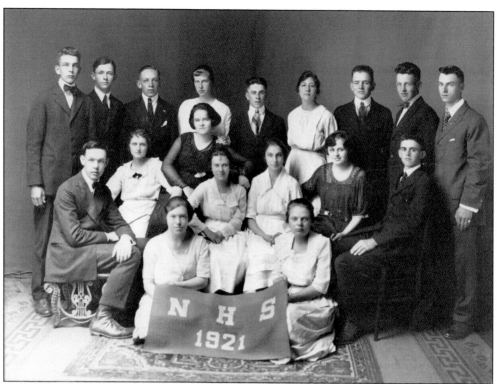

NORTHFIELD HIGH SCHOOL CLASS OF 1921. The town's first high school was built and opened in 1911. Prior to that, students who wanted to continue their education beyond grade school sought private education at Northfield Seminary, Mount Hermon, or one of the academies. By 1921, eight boys and nine girls had completed the requirements for high school graduation. (Courtesy of NHS.)

NORTHFIELD TOWN CENTER, 1950s. The Northfield business district has changed surprisingly little in the past 100 years. At the center of this aerial photograph are the First Parish Church and Webster Block, as well as the rear of the Northfield Town Hall, built after the first town hall was destroyed by fire in 1924. Center Cemetery is at the top of the photograph. (Courtesy of NHS.)

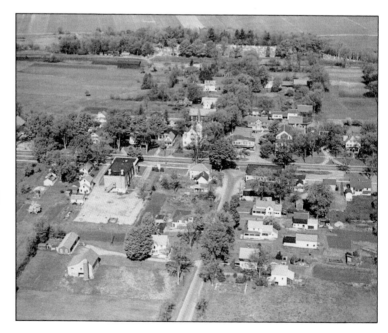

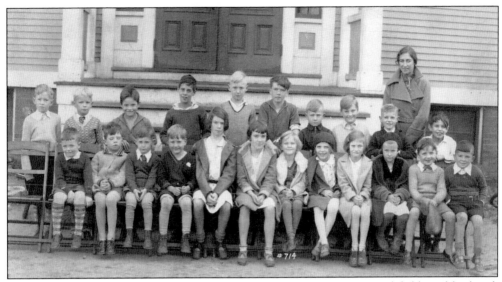

PINE STREET SCHOOL, 1930S. Some of these children lived in the East Northfield neighborhood, within walking distance of Pine Street; others lived across Schell Bridge in West Northfield, riding their bikes or walking across the Connecticut River every day. The Pine Street School building is on the National Register of Historic Places and now houses the Northfield Historical Society Museum. (Courtesy of NHS.)

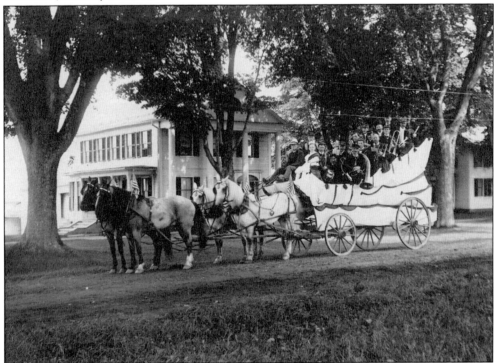

NORTHFIELD TOWN BAND, 1912. During holiday celebrations, Northfield farmers cleaned out the hay wagons and draped them with patriotic colors, put on uniforms, and struck up the band. These residents are stopped in front of one of Northfield's iconic homes, a structure built by Samuel Stearns in 1828 and later sold to William Pomeroy. (Courtesy of NHS.)

Five

TRANSPORTATION
RIVER, RAIL, AND ROADSTERS

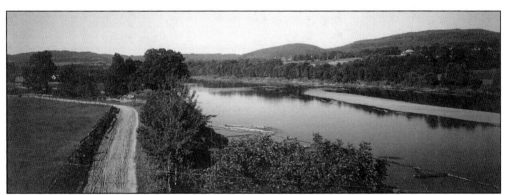

THE RIVER AND COMMERCE. Just as the Connecticut River nourished early Native American and English inhabitants with rich farm fields, in certain seasons, it served as the region's earliest highway. Before the railroad, it provided a means to transport people, goods, and raw materials. As Boston became the primary market for goods, roads were improved and overland shipping by road or railroad replaced the Connecticut River for trade. In its natural state, the river was shallow and rocky and a challenge to navigate. By the early 1800s, dams and canals in Turners Falls had raised the water level to create a means of navigation as well as waterpower. (Courtesy of NHS.)

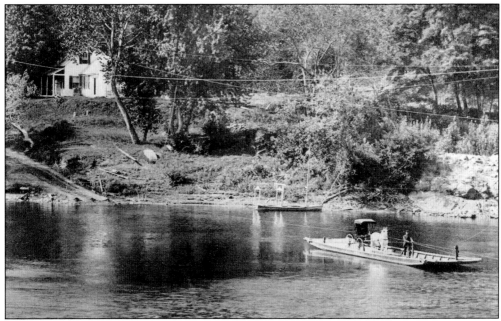

BENNETT MEADOW FERRY. Between 1686 and 1936, seven Northfield ferries operated along the river. This made Northfield a regional crossroads. Stebbins Ferry at Bennett Meadow, established around 1760, was located just north of what is now the Route 10 Bridge. Fares were established according to the cargo being ferried: horses and carriages cost 10¢ to 17¢ per trip, foot passengers paid 3¢, and pigs and sheep cost about a penny. Many former ferry sites are near present-day railroad and vehicular bridges. (Courtesy of NHS.)

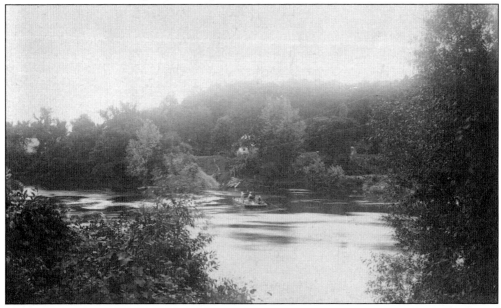

MUNN'S FERRY. Ferrymen were essential to transportation by river, carrying passengers, animals, and freight across the fast-moving water, risking injury and even death. Fred Shantley operated Munn's Ferry between Northfield and Gill from 1912 to 1936. He lost his home in the 1927 flood. Many ferries were known by the names of the ferrymen who operated them. (Courtesy of NMH.)

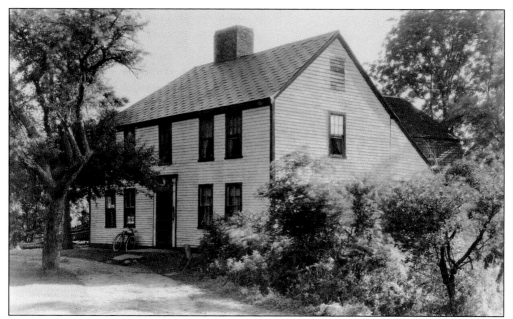

STRATTON TAVERN. Hezekiah Stratton built this house in 1760 for his family. For many years, half of the house was the Stratton Tavern, operated by Hezekiah and his descendants as a place where Northfield Farms neighbors could gather for news. Teamsters stopped here for food and lodging when traveling the north-south route, including via ferry, between settlements in Vermont and New Hampshire and to markets in Massachusetts or Connecticut. (Courtesy of LOC.)

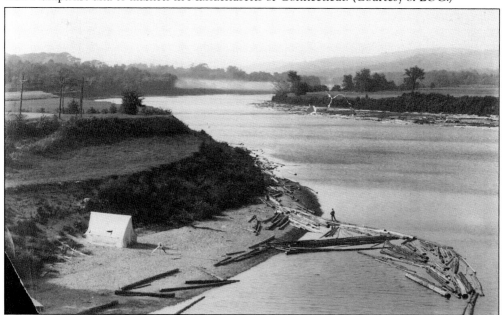

LOG DRIVE NORTHFIELD, 1913. Until 1915, the river was used to transport logs from the northern woods to sawmills near the river, where they would be milled into boards. At the peak of the log drive, workers rode downriver atop the thickly packed logs, breaking up jams with long pikes. The log drives, which could be dangerous, depended on open water. Loggers and other river travelers were a source of news from other towns. (Courtesy of NHS.)

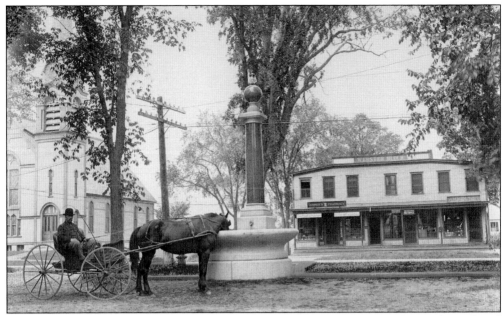

BELCHER FOUNTAIN. Many early residents of Northfield owned and employed horses for work and recreation. Reminders of the horse culture can be seen today. Belcher Fountain, originally located in the middle of Main Street, was essentially an early filling station, providing a convenient means of refreshing horses passing through the center of town. Belcher Fountain is currently installed next to town hall. (Courtesy of NHS.)

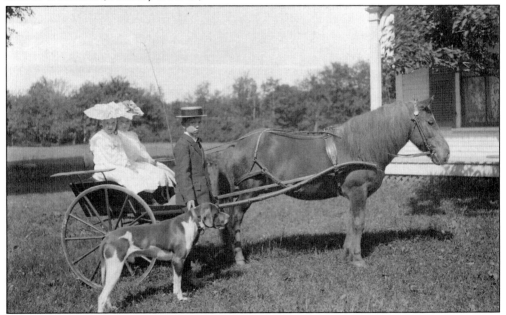

CLAPP FAMILY, C. 1905. As the town grew more prosperous, residents acquired one-horse carts and buggies. Some purchased larger phaetons, which could carry an entire family in style. Carts and buggies were accessible to people of all income levels and could be handled easily by women and children who were not experienced riders. Here, members of the Clapp family of Northfield enjoy a summer outing in their horse cart. (Courtesy of NHS.)

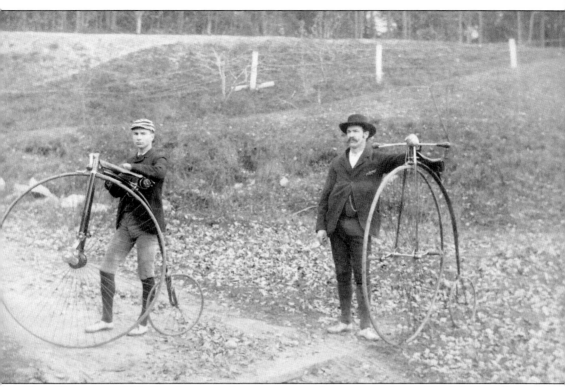

HIGH BICYCLES, 1889. People-powered transportation became popular in Northfield in the mid-1800s. Surprisingly, cycling literally paved the way for later automobile travel, and towns like Northfield used huge horse-drawn rollers to smooth the rutted roads for bicycles. The "high-bicycles" seen here with Frank Goodwin (left) and John E. Nye were built for speed and were primarily ridden by young men, often at their peril. (Courtesy of NHS.)

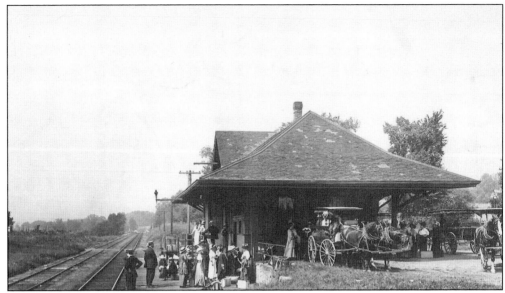

NORTHFIELD RAILROAD STATION. The first passenger station in Northfield was operated by the Central Vermont Railroad (CV) at the end of what is now Parker Avenue, across the tracks from the Northfield Center Cemetery. Beginning in the 1840s, passenger trains ran from New London, Connecticut, to White River Junction, Vermont, via western Massachusetts towns, including Amherst, Millers Falls, and Northfield. After passenger rail service ceased in 1959, the building was moved to Bernardston, Massachusetts, and freight continued to run on the tracks. (Courtesy of NMH.)

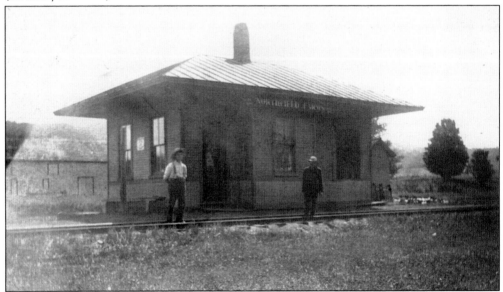

NORTHFIELD FARMS RAILROAD STATION. The need to ship goods and farm commodities over long distances provided the impetus for expanding the railroads, and numerous companies formed to operate lines. After the Northfield station was established, additional stations and flag stops were built in Northfield Farms and across the river to serve Gill and Mount Hermon, Massachusetts, and South Vernon, Vermont. The Northfield Farms station was near the present-day Northfield Mountain Recreation and Environmental Center. (Courtesy of Joel Fowler.)

GILL STATION. This flag stop was particularly useful to travelers who took Munns Ferry to Mount Hermon. The trains brought the world to Northfield, not only in the form of students and teachers from the cities, but also skilled farm workers who emigrated from Ireland, Poland, and French-speaking Canada and found work in Northfield. By the mid-century, 40 Irish immigrant families had resettled in Northfield, prompting the eventual founding of St. Patrick's Catholic Church in 1886. (Courtesy of Joel Fowler.)

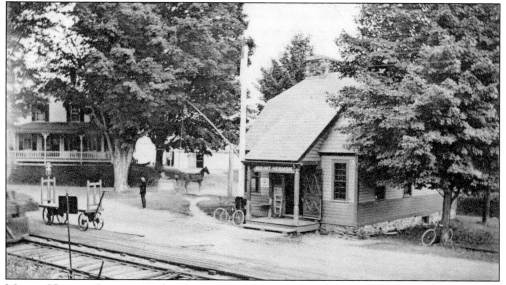

MOUNT HERMON STATION. Railroads constructed most stations to standard specifications. Around 1893, the Moody schools had an architect design the Mount Hermon Station for the stationmaster and his family, with space for ticketing and waiting passengers. Upon completion, Mount Hermon Trustees sold it to the Connecticut River Railroad for $1. By 1910, the station served 10 trains a day. This photograph, taken sometime before 1900, depicts three modes of transportation: horse, bicycle, and train. (Courtesy of NHS.)

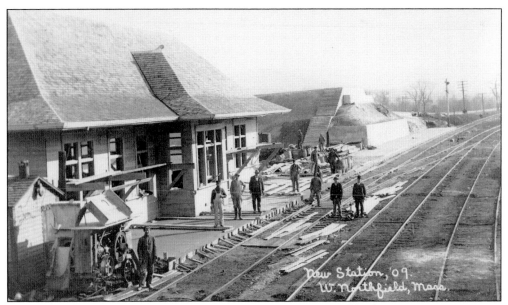

EAST NORTHFIELD STATION, 1909. The Boston & Maine Railroad built its own station in 1909 on the west side of the river, naming it East Northfield Station. It was a short distance from the Central Vermont Railroad's South Vernon Station. More than 40 trains a day stopped at this station, luring much of the lucrative passenger trade away from the CV. Horse-drawn surreys carried visitors over Schell Bridge to the Northfield Inn, to Francis Robert Schell's neighboring chateau, and to the Northfield conferences on campus. (Courtesy of NMH.)

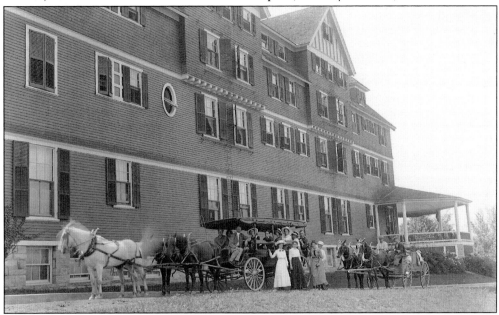

NORTHFIELD HOTEL TRANSFER, 1913. In the summer of 1899, five major activities brought hundreds of visitors to the Northfield Inn and Chateau, including two YMCA events, the 20th anniversary of Northfield Seminary, and several World Conferences for students and adults. In 1910, passengers were carried in horse-drawn "transfers" from the railway station, across the Schell Bridge, to the Northfield Inn and Chateau. (Courtesy of NMH.)

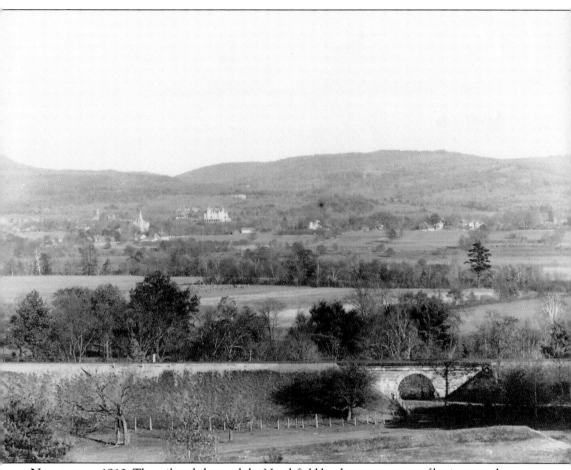

NORTHFIELD, 1910. The railroad changed the Northfield landscape, patterns of business, and even peoples' lives at home. In the foreground, the Boston & Maine Railroad line passes over Caldwell Road in West Northfield. This line was one of several responsible for the changing landscape of Northfield that can be seen across the river: Schell's Chateau, the Northfield Hotel/Inn, and the Northfield campus. When Dwight L. Moody returned to Northfield in 1869, he arrived by train. His grand visions for Northfield Seminary, Mount Hermon School, the conferences, and the hotel were dependent upon the railroad and its connection with cities. Trains also transported to market many commodities originating in Northfield, including ice, lumber, grain, meat, and produce. The coming of the railroad drove the socioeconomic changes in Northfield's agricultural businesses and the development of East Northfield as a center for education and tourism. (Courtesy of NMH.)

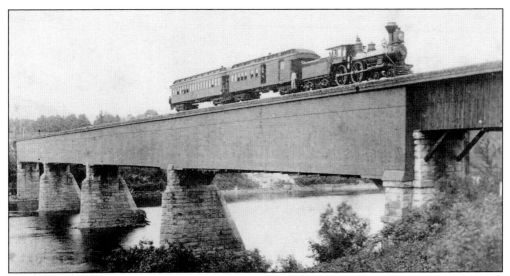

VERMONT & MASSACHUSETTS RAILROAD BRIDGE. In 1846, private investors gained authorization from the legislature to build a double-decker toll bridge over the Connecticut River between Prindle's Ferry on the west side and Mill Brook. The investors sold the bridge to the Vermont & Massachusetts Railroad in 1848. Horse-drawn wagons traversed what was essentially a long, dark tunnel below train tracks that ran overhead. A common complaint was that the horses were spooked by the enclosed space. Passengers complained about hot coals falling through the tracks onto their carriages. A toll was taken, but travel to church was exempted from tolls. (Courtesy of NHS.)

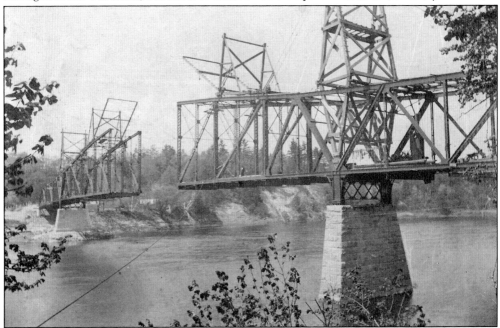

MOUNT HERMON–BENNETT MEADOW BRIDGE. In 1899, Northfield voters agreed to a levy for a vehicular bridge just above the Bennett Meadow Ferry, also known as the Mount Hermon Bridge. A year later, townspeople refused a request from the Central Vermont Railroad to help repair its bridge near Mill Brook. Therefore, in 1903, the CV rebuilt its structure exclusively for train traffic. (Courtesy of NHS.)

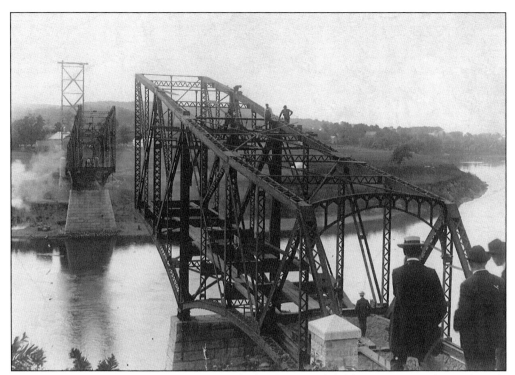

BUILDING THE SCHELL BRIDGE, 1902. With the East Northfield train station almost directly across from the chateau and the campus, the decision to change the railroad bridge meant that thousands of visitors arriving at the East Northfield Station would have to travel many miles down to the new Mount Hermon Bridge to get into the village. Wealthy industrialist Francis Robert Schell, who was building the chateau, offered to pay for the building of a bridge for pedestrian and vehicular traffic if it could be sited to showcase the campus. (Courtesy of NMH.)

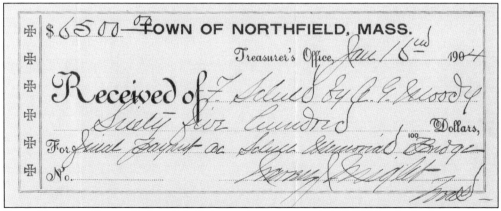

FINAL PAYMENT. Francis Robert Schell donated approximately $60,000 for the bridge in a series of payments. This receipt for $6,500 documents the final payment to the town in care of Ambert Moody, nephew of D.L. Moody. The bridge was closed in 1987 because it was deemed unusable. The town is currently pursuing a bikeway replacement for the venerable bridge. (Courtesy of NMH.)

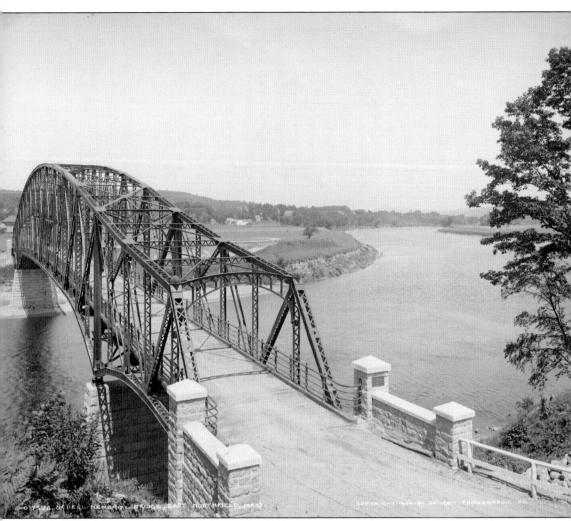

SCHELL MEMORIAL BRIDGE OPENS, 1904. This ornate Pennsylvania truss bridge was finished in 1904 and dedicated to the memory of Schell's parents. It was quite similar to the Mount Hermon Bridge several miles south, with the addition of Gothic elements such as the trefoils on the top of the entrance and an archway in the center. Designed by Edward S. Shaw, the bridge was a cantilever steel truss bridge, 515 feet long with a graceful span, giving it a light and airy appearance. It was described as having an artistic effect with beautiful details. This was a significant achievement, not only for visitors' convenience, but also for people who lived in West Northfield, who could now more easily visit East Northfield. (Courtesy of LOC.)

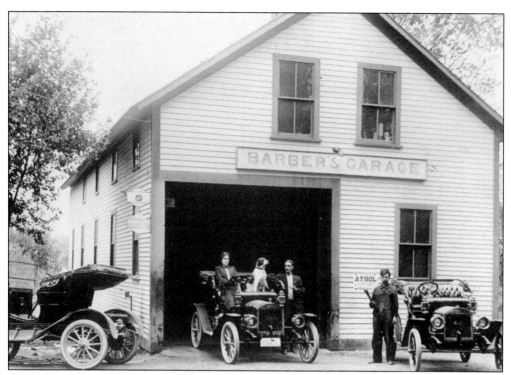

Automobiles in Northfield. Roughly 50 years after the introduction of the railroad, the automobile came to Northfield. Throughout the region, small manufacturers tried fabricating the new vehicles, and every town had more than one entrepreneur who saw opportunity in their constant need for repair and maintenance. Barber's Garage, then located on the corner of Main and School Streets, is shown here. Posing in front of the building are Catherine "Kate" Newton Barber and John Barber in the car and an unidentified mechanic. (Courtesy of NHS.)

First Woman Driver. By 1904, nearly 60 different horseless carriage models were available to markets in the United States. In Northfield, Catherine Kate Newton Barber was the first woman to own an automobile in town. She is pictured here in her 1911 Maxwell runabout. One of the top three automakers of the day, Maxwell had sponsored the first cross-country drive by a woman in 1909. (Courtesy of NHS.)

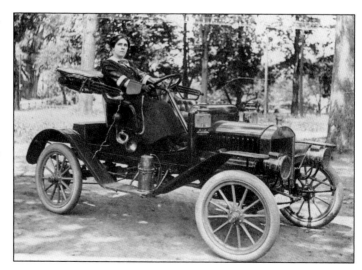

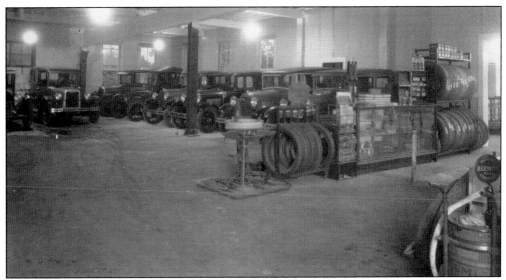

SPENCER BROTHERS GARAGE, 1920s. As car ownership came within the reach of average citizens, automobile and tractor dealerships sprang up in Northfield. Gas stations and repair shops opened in East Northfield, Northfield Center, and Northfield Farms. Spencer Brothers had a long history as the local Ford dealer. In the 1920s, Henry Ford sold the Model T "in every color, so long as it's black." (Courtesy of NHS.)

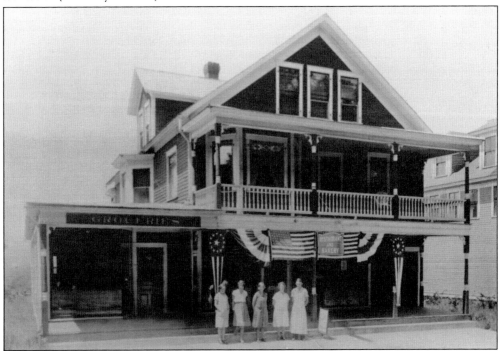

BUFFUM'S. Clarence P. Buffum operated a general store here after his father built it sometime after 1910. His father later built a grocery department on the south side. In this photograph, taken after the general store closed in the 1920s, are Helen and Norman Whitney on the right with their employees at their restaurant and bakery. Later, it became a hardware, plumbing business, and a hair salon. (Courtesy of L. Steiner.)

Six

Dwight L. Moody
Native Son

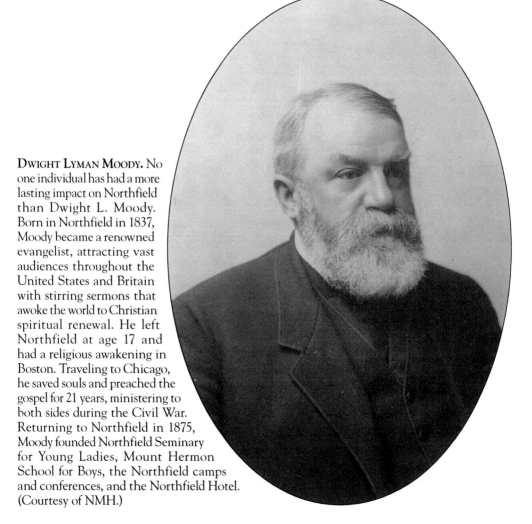

Dwight Lyman Moody. No one individual has had a more lasting impact on Northfield than Dwight L. Moody. Born in Northfield in 1837, Moody became a renowned evangelist, attracting vast audiences throughout the United States and Britain with stirring sermons that awoke the world to Christian spiritual renewal. He left Northfield at age 17 and had a religious awakening in Boston. Traveling to Chicago, he saved souls and preached the gospel for 21 years, ministering to both sides during the Civil War. Returning to Northfield in 1875, Moody founded Northfield Seminary for Young Ladies, Mount Hermon School for Boys, the Northfield camps and conferences, and the Northfield Hotel. (Courtesy of NMH.)

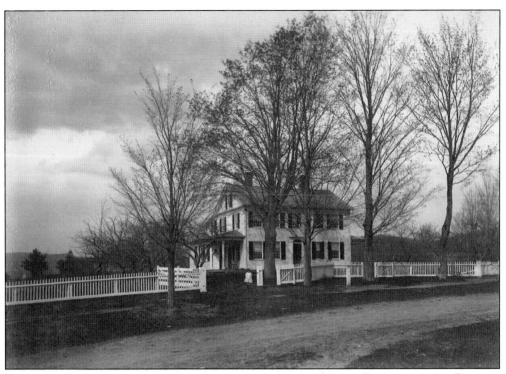

MOODY BIRTHPLACE AND BETSY HOLTON MOODY. Dwight L. Moody was born in 1837 to Edwin and Betsy Holton Moody, the sixth of their nine children. They operated a family farm, with Edwin supporting the family as a stonemason until his sudden death in 1841. The family lost everything, save the house, to creditors. The home is seen above in 1891. Despite their grief, all the children, including Dwight, went to work, earning pennies to help support the family. Dwight L. Moody was devoted to his mother. At the end of her life, when her famous son was back living in Northfield, Moody never failed to pay her a daily visit. She died in 1896, and Moody gave a special eulogy. (Both, courtesy of NMH.)

FIRST PARISH UNITARIAN, 1872. The First Parish Unitarian Church and its new minister, Rev. Dwight Everett, brought Betsy Moody and her family into the church, providing faith and sustenance after Edwin's death. The Moody children were baptized and attended Sunday school here. Built in 1832, the structure's belfry housed a bell cast by Paul Revere. This church stands today at the town center and houses the town clock. (Courtesy of NHS.)

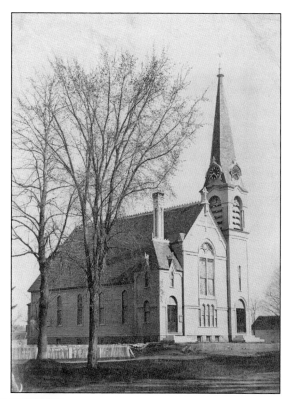

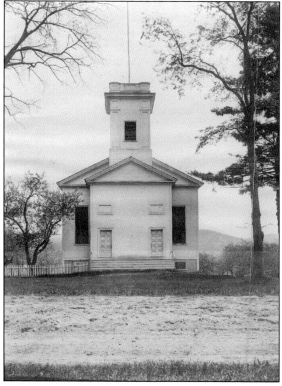

FIRST TRINITARIAN CHURCH. In 1825, the Trinitarian Society of Northfield was formed when 30 members of First Parish broke away over the doctrine of Unitarianism. It was to this church, built in 1829, that Moody returned after his evangelical mission in the United States and Britain. By 1889, the first church had become too small for the numbers of students attending from Northfield Seminary and Mount Hermon, and a new church was built. (Courtesy of NHS.)

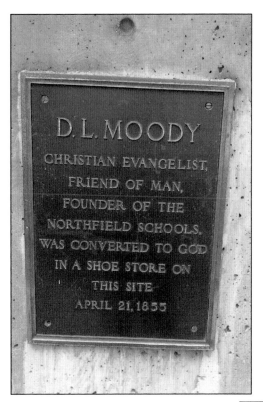

MOODY'S CONVERSION. At age 17, after Dwight L. Moody left Northfield for Boston to become a shoe merchant, he worked for his uncle, Samuel Holton. It was in Boston that he began to commit his life to Christ. As a condition of his employment, Moody attended Mount Vernon Congregational Church and became part of the Sunday school class taught by Edward Kimball. On April 21, 1855, Kimball visited the Holton Shoe Store, found Moody in a stockroom, and spoke to him of the love of Christ. Shortly thereafter, Moody accepted that love and devoted his life to serving God. (Courtesy of LOC.)

EMMA REVELL MOODY. Dwight L. Moody met Emma C. Revell in Chicago and married her on August 28, 1862. Emma was the daughter of a wealthy English industrialist. They had a daughter, Emma, and two sons, William and Paul. Emma was quiet, graceful, and charming, and she supported her husband's endeavors. (Courtesy of NMH.)

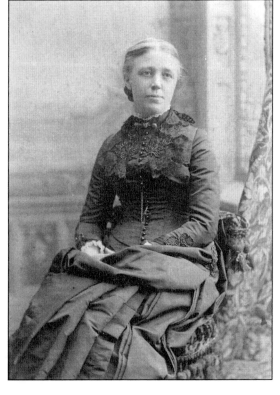

IRA SANKEY, 1895. Moody met Ira Sankey, a Civil War veteran, in 1870. They attended evangelistic meetings together and later led them. Sankey was a gospel singer and composed the collection *Gospel Hymns*, which sold 60 million copies. The royalties from hymnbooks help to fund the Northfield Seminary campus buildings. Together, the two traveled to the United Kingdom. Sankey led the hymns, and Moody preached. At the Northfield conferences, they continued as a team. (Courtesy of LOC.)

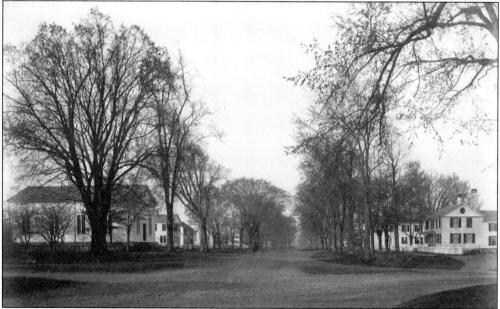

SANKEY HOUSE, 1885. In 1882, Sankey bought the house next to the First Parish Unitarian Church (out of view on the right) and became a respected individual in town. Coincidentally, Moody also knew this house, as it has been the residence of Reverend Everett, who was so helpful to his family after his father died. Across the road was the town hall, which was destroyed by fire in 1924. Sankey died in 1908. (Courtesy of NMH.)

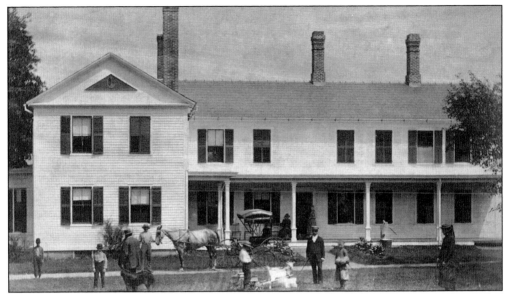

MOODY HOMESTEAD, 1890. After years traveling as an evangelist, Dwight L. Moody and his wife, Emma, returned to Northfield and bought a house and land for $3,500 in 1875 from Elisha Alexander Jr. The house was built in 1829 by Northfield housewrights Calvin and Samuel Stearns for Elisha Alexander Sr. and his wife, Sarah Doolittle. This was "home" whenever the Moodys were in Northfield. (Courtesy of NMH.)

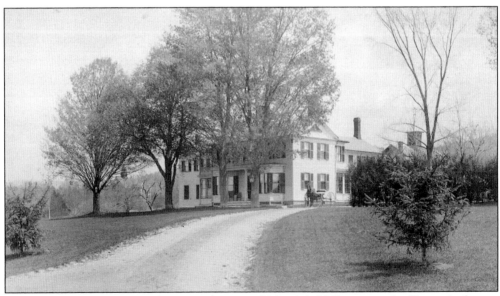

THE HOMESTEAD, 1885. When Moody opened Northfield Seminary for Young Ladies in 1879, the Homestead became the first classroom building. On the second floor of the ell, 10 dormitory rooms, called "Penny Alley," were constructed. Chapel services were held in the dining room. (Courtesy of NMH.)

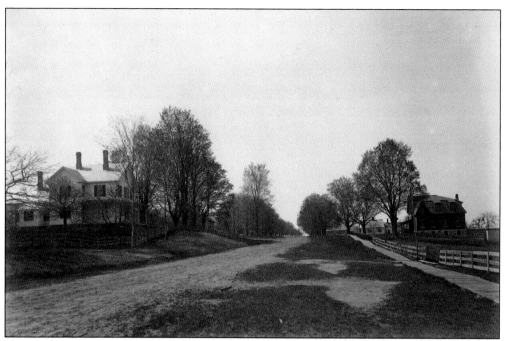

MAIN STREET, 1885. This south-facing photograph was taken near the Homestead. The house on the left was owned by Edwin Moody's youngest brother, Medad A. Moody. Medad, the good-natured and quick-witted uncle of Dwight L. Moody, was a brick mason by trade. This house was moved to land owned by Will Moody sometime after 1902, when Birnam Road was built. At the new location, the side of the home facing south in this photograph was placed so that it fronts Birnam Road. (Courtesy of NMH.)

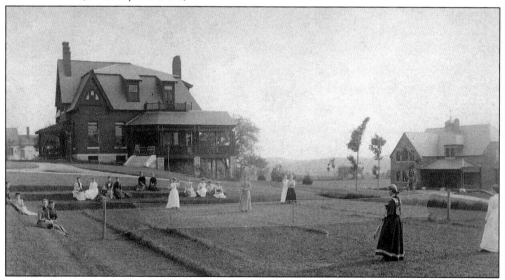

REVELL AND HOLTON HALLS, 1891. Northfield Seminary's first classroom building, Recitation Hall, was finished in 1879. The seminary girls take their required half-hour of outdoor exercise outside Revell Hall (left), renamed for Dwight L. Moody's brother-in-law Fleming Revell. Holton Hall (extreme right), seen behind Revell Hall (extreme left), was originally the carriage house. (Courtesy of NMH.)

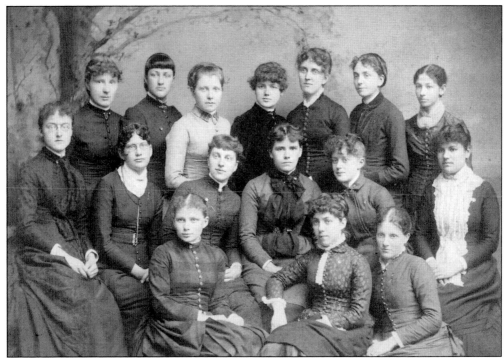

CLASS OF 1885. The young women in this class entered Northfield Seminary from poor farming families, without the advantages available to wealthy families. The class included young women of several races. The girls graduated with a Christian education and were trained for fulfilling lives in service as teachers and missionaries. (Courtesy of NHS.)

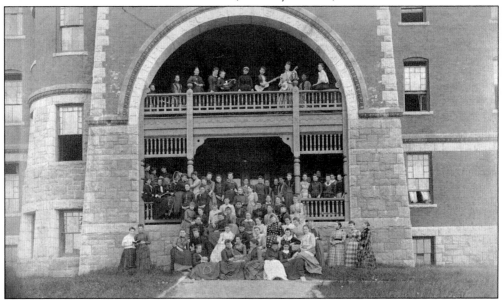

MARQUAND, 1889. With every new building, the scale of the seminary campus grew. In 1884, Marquand was built. It housed 83 students and was the largest building on campus. Tuition was $100 per year, which covered only half the expenses. The rest of the costs were covered by a small endowment and by royalties from the sale of hymnals. (Courtesy of NMH.)

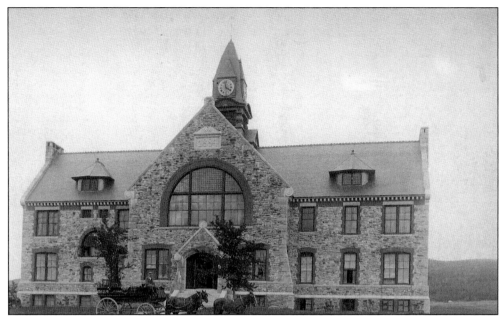

STONE HALL. This building replaced Recitation Hall in 1885. Built from native granite stone quarried less than two miles from the campus, Stone Hall provided 12 more classrooms for the growing seminary population. Bible study was emphasized in daily classroom lessons. In all the years that the campus was active, this symmetrical Queen Anne–style building was a favorite of students and teachers because of its intimate classrooms and the clock that kept everyone on time. (Courtesy of NMH.)

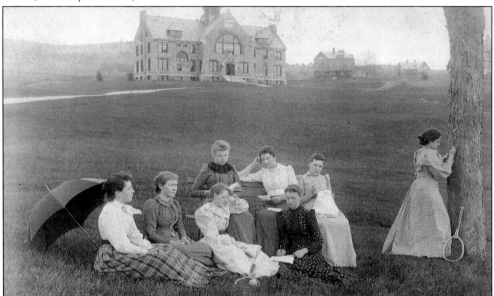

SEMINARY GIRLS, 1893. Young ladies of Marquand enjoy an afternoon of leisure within view of Stone Hall. Women's education was in its infancy, and most of the young ladies were near college age, like those at Mount Holyoke and Wellesley. Some say the memory of hymn singing is so vivid that the music of girls' voices can still be heard through this part of the campus. (Courtesy of NMH.)

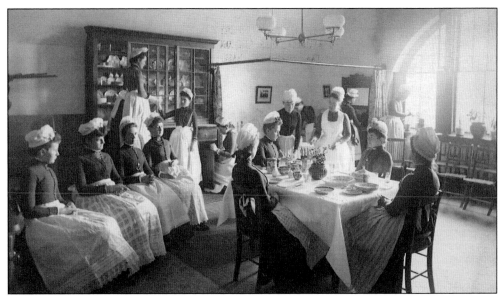

MARQUAND ATTIC, DOMESTIC SCIENCE, 1889. All students learned the household duties of cooking, sewing, washing, ironing, and housecleaning, and they contributed to the daily work of the school. In order not to confuse this class with a program in training domestics, in which students learned household service skills, its name was soon changed to household science. In later years, students had a "work-job" to perform every day, maintaining the tradition of educating the head, heart, and hand. (Courtesy of NMH.)

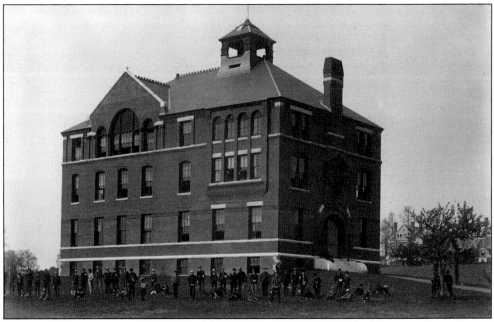

MOUNT HERMON RECITATION HALL, 1885. While building construction was taking place at Northfield Seminary, Mount Hermon School for Boys had begun in 1881 under the guidance of Dwight L. Moody. Mount Hermon had a very different kind of educational operation than Northfield Seminary, but the two schools were yoked to their common founder, and they supported one another as they grew. (Courtesy of NMH.)

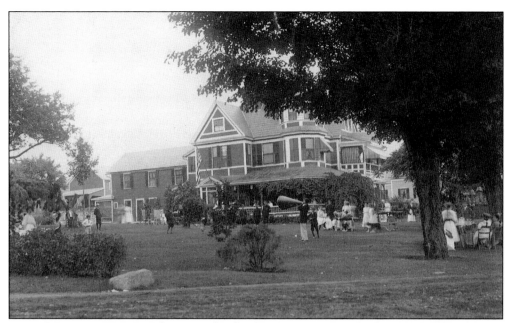

GREEN PASTURES, 1886. Dwight L. Moody's daughter, Emma, and her husband, A.P. Fitt, purchased this house as a summer home in 1895. When the house passed to their daughter, also named Emma, and her husband, Edward Powell, in 1930, the Powells named it Green Pastures and enjoyed it with their four children. The house was the center of many celebrations, parties, and even a circus with a baby elephant. During the summer, the house was filled with vacationing guests. (Courtesy of NMH.)

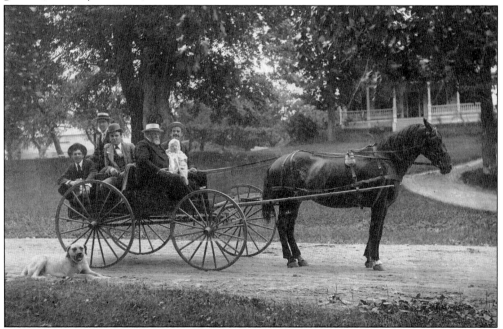

MOODY IN NORTHFIELD, 1890s. At the end of the day, nothing gave Dwight L. Moody greater pleasure than to take his family for a ride around Northfield. Here, his granddaughter is on his knee as his dog Lion follows along. (Courtesy of NMH.)

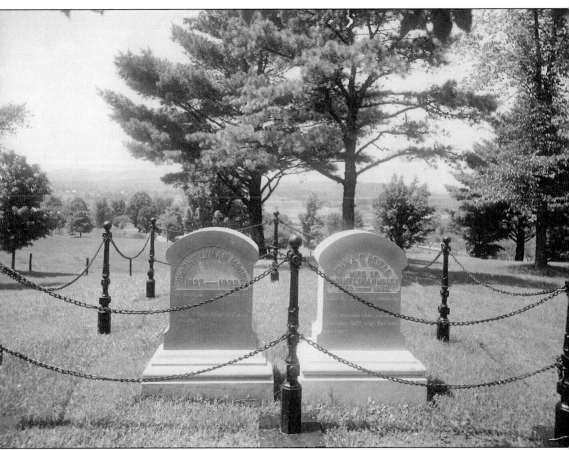

Graves on Round Top, 1910. After a period of failing health while he was traveling, Dwight L. Moody was brought back to Northfield. He never recovered and died on December 22, 1899. Dignitaries gathered hastily for the funeral and internment, held the day after Christmas. Tributes to a great man appeared in many newspapers in the United States and Britain. His wife, Emma Revell Moody, was laid to rest beside her husband four years later. To this day, Christians from around the world come to this hallowed ground not far from the house in which Moody was born. Northfield Mount Hermon School celebrates Founders Day every February 5. A plaque honoring Moody can be seen at the Northfield Town Hall. Today, the Rustic Ridge Association still conducts hymn sings there in the Moody tradition. (Courtesy of NMH.)

Seven

CAMPS AND CONFERENCES
HEAVEN ON EARTH

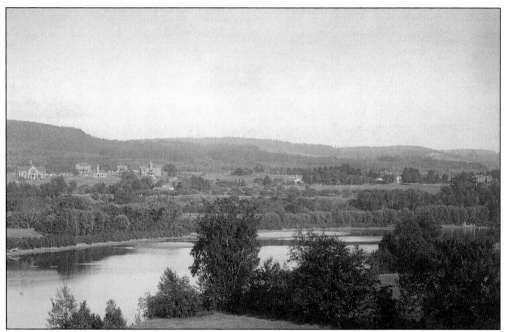

VIEW FROM WEST NORTHFIELD. Growing activity on the Northfield Seminary campus during the late 19th century overwhelmed the small agricultural community of Northfield, but it also contributed to the local economy. The campus drew thousands of Moody followers to the Summer Conferences beginning in 1881. In the late 19th century, Northfield was poised to expand rapidly from a sleepy agricultural village to a world-class destination for religious renewal and summer recreation. The summer conferences were enjoyed by thousands of Moody followers and lasted into the middle of the 20th century. (Courtesy of NMH.)

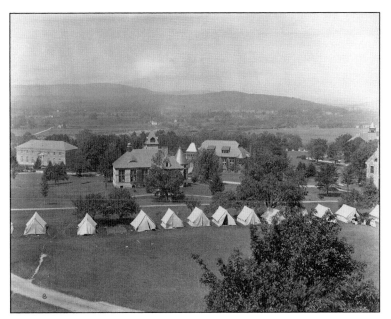

TENT VILLAGES. It had always been Dwight L. Moody's intention to utilize the Northfield Seminary buildings and grounds during the summer for Summer Conferences. At the first conference in 1881, East Hall could not accommodate all who came, so tents were set up. Tents became a tradition thereafter. (Courtesy of NMH.)

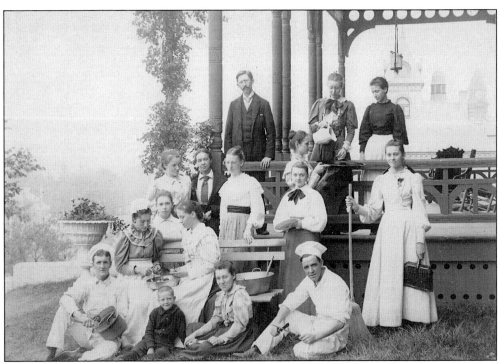

SUMMER CONFERENCE WORKERS, 1890S. Workers were drawn from Northfield Seminary and Mount Hermon School student applicants. The staff worked throughout the summer to ensure that conference participants were comfortable and well fed. By 1935, the conference staff had grown to represent some of the best colleges in the Northeast. Many summer romances developed into lifetime marriages. (Courtesy of NMH.)

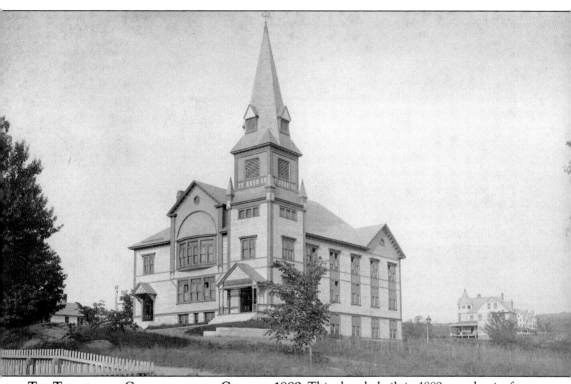

THE TRINITARIAN CONGREGATIONAL CHURCH, 1889. This church, built in 1889, was the site for much of Dwight L. Moody's preaching when he was in Northfield. It was built with a sanctuary that could seat 1,200 to accommodate the boys and girls from Mount Hermon and the Northfield Seminary. Despite its size, it could not accommodate the crowds of people who wanted to hear Moody speak during the Summer Conferences, and a large tent was pitched next to East Hall. For many years, this church was filled in the summer months. After both schools built their own chapels, the church was far too large. Before it was destroyed by fire in 1978, it served as an active community center, hosting special events for senior citizens and other community groups. (Courtesy of NMH.)

THE AUDITORIUM. Built in 1894, this campus structure seated 2,500 people and was erected primarily to serve the throngs attending the Summer Conferences. Doors along the sides of the building opened to provide breezes for the Moody followers who attended meetings and heard scriptures and sermons morning, afternoon, and evening. In the below photograph, Moody is on stage, seated fourth from right. Ira Sankey, organist and hymn leader, is seated second from left. Throughout the life of the Northfield campus, the Auditorium was the site for the spring Concert of Sacred Music and for convocations, concerts, commencements, and other significant events at the schools. (Both, courtesy of NMH.)

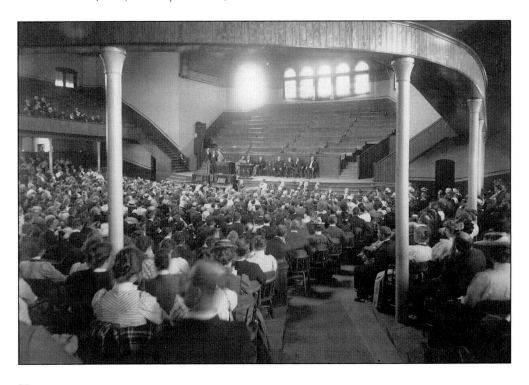

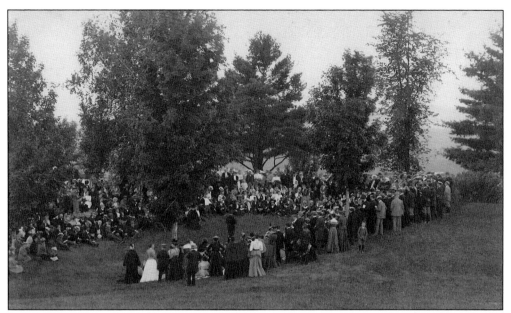

ROUND TOP. Throughout the Summer Conferences season, sunset services were held on Round Top, sometimes with Dwight L. Moody present. Situated at a high point on the Northfield campus, Round Top awards its visitors with a spectacularly scenic view of the Connecticut River Valley looking north, and of the distant Vermont hills and mountains to the west. Today, memorial services and other commemorative events are still held on Round Top. (Courtesy of NMH.)

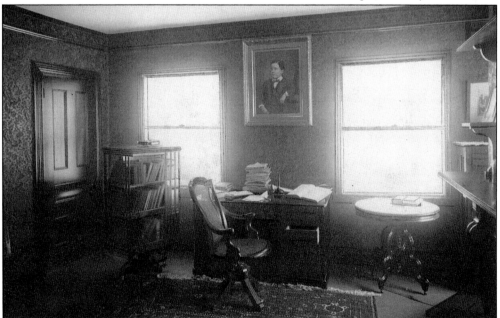

DWIGHT L. MOODY STUDY. Moody traveled far from Northfield to speak throughout the United States and in England and other parts of the world. When he was at home in the Homestead, this was his study. Here, he prepared for his next speaking engagements. Moody's desk, bookcase, chair, and books are all preserved at the Moody Birthplace and Museum, which is open by appointment. (Courtesy of NMH.)

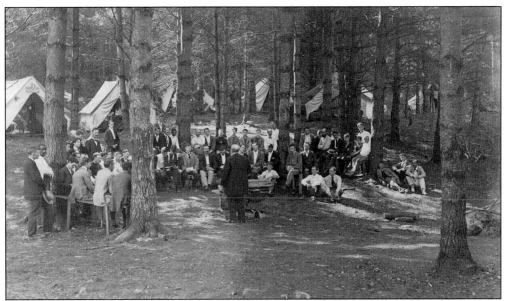

MORNING MEETING AT CAMP NORTHFIELD, 1890s. Dwight L. Moody often arrived at Camp Northfield, amid the pines and birches, in time for morning devotions. The camp, situated on a shoulder of Strobridge Hill at the end of Pine Street, a short walk from Garnet Rock, served a variety of groups at different times. Here, Moody meets with men who worked in stores and offices, vacationing under the sponsorship of the YMCA. They rented tents for $2 a week and boarded in a cooperative dining hall for $3 a week. (Courtesy of NMH.)

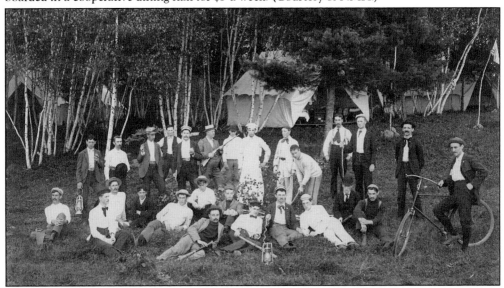

CAMP NORTHFIELD, 1895. Dwight L. Moody thought it would be helpful for young men to get away from the cities for a week or two for worship, fellowship, and recreation. Camp Northfield opened on July 9, 1895, and had a total attendance of about 700 for the summer. Campers hiked, played baseball, swam, and attended the Summer Conference meetings in the auditorium. The camp was located in the woods at the end of Pine Street, beneath the tall pines. It is not to be confused with today's Camp Northfield on Route 10, which was once Louise Andrews Camp. (Courtesy of NMH.)

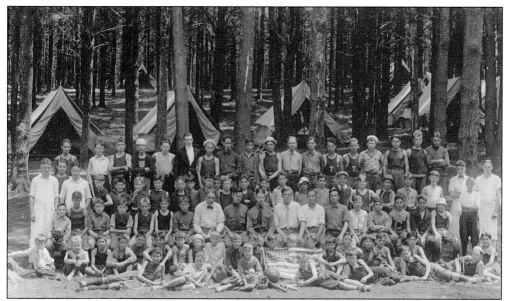

CAMP NORTHFIELD, C. 1917. Because of Moody's interest in serving the needy, he started Camp Northfield as a means to help guide college students and young working people toward Christ-centered lives. After Moody's death, the camps continued to operate, serving veterans of World War I. Summer camps provided opportunities for all to experience the serenity and beauty of Northfield and to partake in the offerings at the Summer Conference meetings. (Courtesy of NMH.)

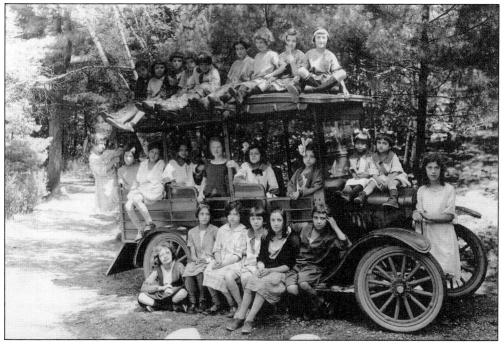

VIRGINIA FRESH AIR CAMP, 1923. Virginia Camp used the facilities of Camp Northfield and the nearby home once owned by Will Moody. Virginia Camp provided an opportunity for girls from the cities to enjoy summer in the country with good food and fun. They occupied some of the same rustic buildings used by YMCA groups and college men in an earlier era. (Courtesy of NMH.)

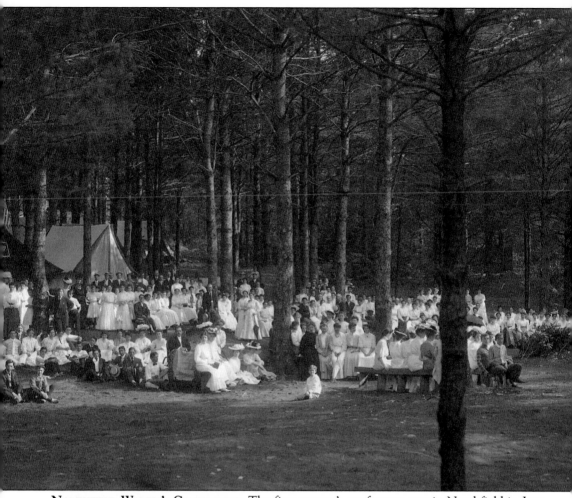

NORTHFIELD WOMEN'S CONFERENCE. The first women's conference met in Northfield in June 1893, attended by about 200 girls from schools and colleges. It was developed in direct response to women's requests that Moody organize a conference for women similar to the conference for men at Mount Hermon. The program included Bible classes on the themes of Christian life, Christian service, missionary life, Bible study, and more. Here, the women gather with the men amid the pines at Camp Northfield. May Whittle, who was instrumental in organizing the first conference, later married Will Moody, Dwight's oldest son, who succeeded Moody as head of the schools. The young women who attended this conference, some of the first women to attend college, were taken seriously by men at the Summer Conferences. (Courtesy of NMH.)

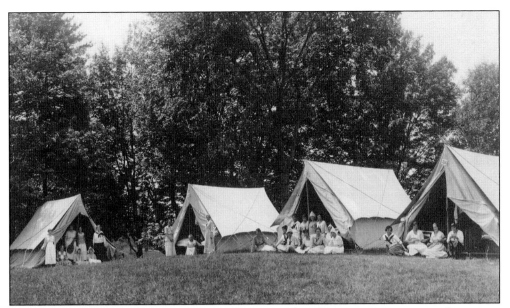

CONFERENCE OPPORTUNITIES FOR WOMEN. For many decades, tents were set up each summer to provide beds for the General Conference for Christian Workers, the Student Conference, a Young Women's Conference, a Women's Home Missionary Conference, a Summer School for Sunday School Workers, and a Summer School for Women's Foreign Missionary Societies. (Courtesy of NMH.)

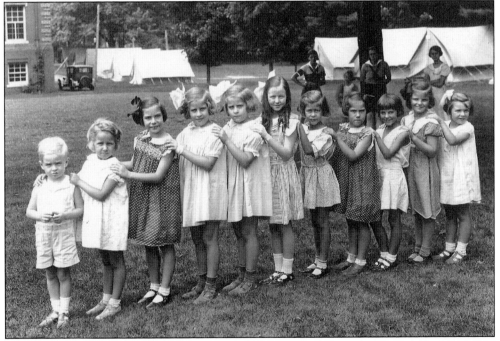

THE CHILDREN'S HOUR. Between the wars, whole families took their vacations on the Northfield campus. Parents attended the discussions and events in the auditorium while children attended religious education classes appropriate for their ages. It is possible to see that some of the children here are related. (Courtesy of NMH.)

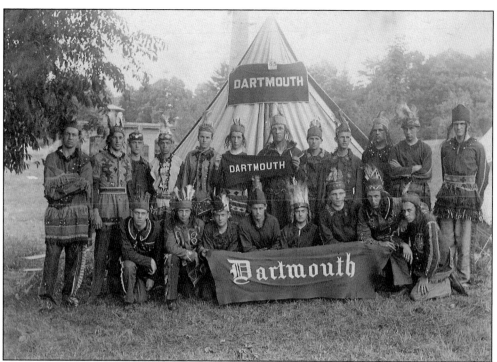

YMCA Men's Conference. From 1886, when the first YMCA Men's Conference for college students was held at Mount Hermon, until well into the 20th century, young men from the nation's most prestigious colleges and universities rallied together to attend conferences held every June on the Northfield campus. In addition to Bible study, there were meetings as well as fun and recreation. These gatherings led to the formation of the World's Student Christian Federation and the Student Volunteer Movement. (Courtesy of NMH.)

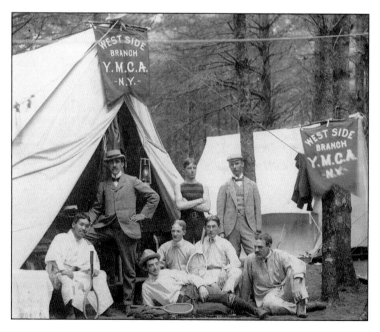

Camp Northfield and YMCA. Dwight L. Moody's association with the YMCA began when he was a conscientious objector during the Civil War. As an alternative to serving, he worked with the US Christian Commission of the YMCA, visiting soldiers on the battlefield. Camp Northfield was a natural outgrowth from that experience of helping young men who were far from home and family. (Courtesy of NMH.)

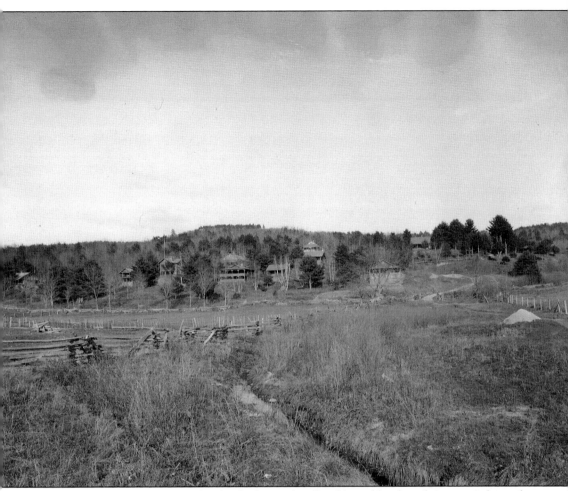

RUSTIC RIDGE. In the summer before he died, Moody offered leased land on the western slope of Notch Mountain for the building of summer cottages for those attending the Summer Conferences. Under the management of Moody's nephew Ambert, by 1904, land had been added to meet demand. Cottages were built in the area, to be known as Rustic Ridge. Building took place at two other developments, Mountain Park and the Highlands, although they were not fully sold. This 1910 photograph shows the rusticated cottages just above the Moody pasture. Bark slab exterior siding and clever windows characterize these cottages. Their water supplies are seasonal, and the roads are unplowed in the winter. Descendents of the first owners continue to spend their summers in these cottages. Their parents, grandparents, and great-grandparents were some of the important religious leaders at the conferences. (Courtesy of NMH.)

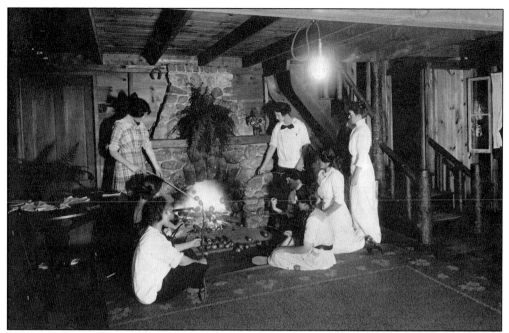

BETHANY COTTAGE. Up Winchester Road, another small area of 11 cottages, called the Highlands, was built between 1903 and 1907 on the same hillside. These girls roasting apples were part of Bethany Camp. Note the interior of this cottage, with the stone fireplace and posts of unpeeled bark. These features are characteristic of most of the early cottages. After this cottage was destroyed by fire, a newer cottage was built around the original fireplace and chimney. (Courtesy of R. Brown.)

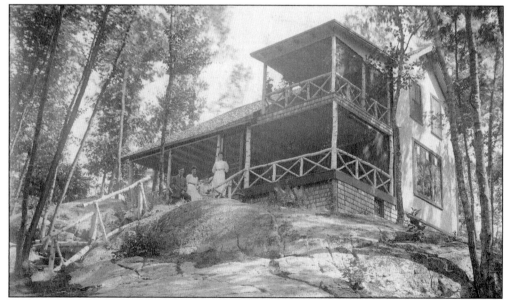

GREYLEDGE. Built on a slab of rock in the Highlands, this was a cottage with a view. Note the extensive use of unpeeled logs. This cottage has been in the same family since 1913, and all of the family members attended the Summer Conferences until they ceased operations. (Courtesy of NHS.)

BONNYBLINK.
KENT LODGE.

THESE two houses will be conducted under the same management, from June 1. We solicit the patronage of those who desire the comforts of a restful, quiet summer home and are willing to pay for same.

BONNYBLINK

AMPLE SPACE
NO CROWDING
FIRST-CLASS SERVICE
EXCELLENT HOME TABLE
A PUBLIC AUTOMOBILE
DRIVING, TENNIS, CROQUET

Mrs. D. N. Selleg Miss M. P. Thomson

KENT LODGE

BONNYBLINK AND KENT LODGE. Because accommodations for the Summer Conferences were so scarce, Moody and the conference organizers asked for townspeople to rent rooms if they had them. Moody also offered land free to those who would build large houses that could accommodate boarders. Bonnyblink was built under those terms, in 1890, on Moody-owned land across from the Northfield Hotel/Inn that had been erected in 1888. Kent Lodge catered to Summer Conference attendees and housed seminary students during the school year. (Courtesy of NHS.)

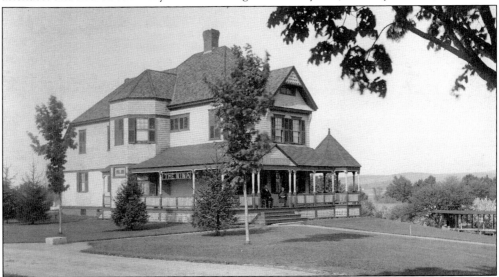

THE NINA. This house, known as Moore Cottage, was first owned by Northfield and Mount Hermon's music and choral director, A.J. Philips. He sold the house to D.L. Griggs, who developed it as a boardinghouse for the Summer Conferences. No alcohol, tobacco, profanity, or card playing were allowed here. Eventually, it returned to school use as a dormitory. It served as a guesthouse for visitors to the schools in later years. (Courtesy of NMH.)

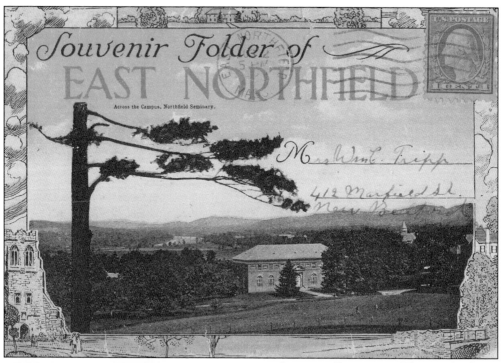

Across the Campus, Northfield Seminary.

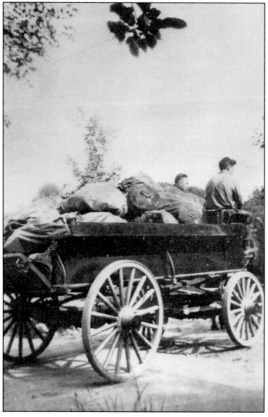

LEVERING POSTCARDS. Thousands of scenic postcards were purchased and sent by Summer Conference attendees. A.R. Levering, a local photographer who documented much of early East Northfield, had a studio on Winchester Road, across from the Auditorium. He produced and sold hundreds of different scenic cards. These were received and saved by friends and relatives all over the United States, and they have since reappeared, to the delight of antique postcard collectors. (Courtesy of NHS.)

MAIL FROM EAST NORTHFIELD. Mail overwhelmed the postal system on July 1, 1919, when postal workers processed 90,000 pieces of outgoing mail from the local post offices. The East Northfield Post Office, established in 1891, was located in the Bookstore building. Northfield's main post office was established in 1797 in the Webster Block in the center of town. There were also post offices in West Northfield, Northfield Farms, and Mount Hermon. (Courtesy of NHS.)

Eight

NORTHFIELD
NORTHFIELD HOTEL AND CHATEAU

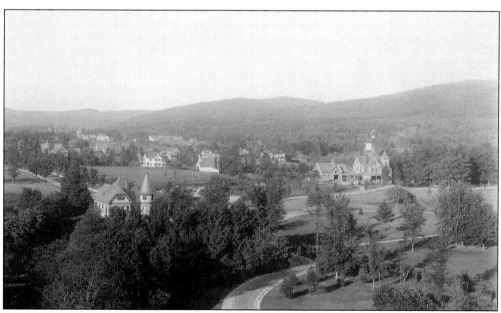

EAST NORTHFIELD, 1907. The Summer Conferences ushered in an era of unprecedented building in East Northfield. Within a very short time, East Northfield had its own post office and stores, railroad station, and the Schell Memorial Bridge to transport train travelers. Streets were laid out for the new homes and summer cottages. According to *New England* magazine in 1897, "The old families of Northfield, descendants of the original settlers [were] rolling their eyes in amazement at the changes in the sleepy little village." (Courtesy of NHS.)

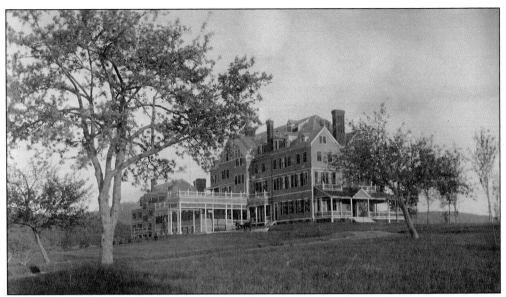

THE NORTHFIELD, 1890s. The Northfield (later called the Northfield Inn) was built in 1888 with 39 bedrooms. Standing on 60 acres of land, it initially provided summer resort lodging and recreation for Moody followers who were averse to staying in tents on the campus. Not long after this photograph was taken, the hotel underwent an expansion because of its popularity. It became an important employer in the town and developed many recreational resources for golf, swimming, and hiking, which continue to be enjoyed today. (Courtesy of NMH.)

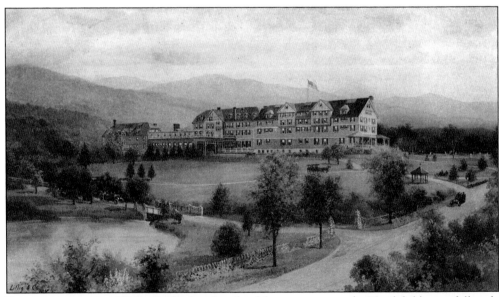

EARLY ADVERTISING, 1900s. By the first decade of the new century, the Northfield was a full-scale resort trying to rival destinations like the newly opened Mount Washington Hotel in Bretton Woods, New Hampshire. This romanticized view of the Northfield shows an elegant setting; the Northfield hills appear to be as high as the White Mountains. The management need not have worried, for no resort hotel could compete with the Northfield's accessibility to the most famous evangelist of the era, Dwight L. Moody. (Courtesy of NMH.)

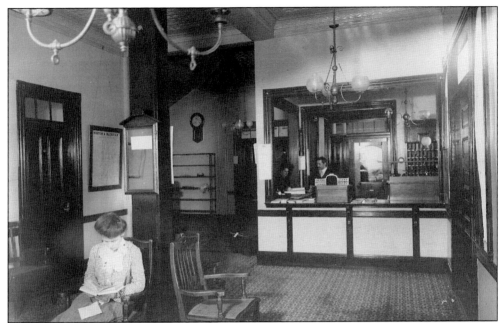

THE NORTHFIELD LOBBY. Upon arrival at the Northfield, patrons would register by signing a guest book. The guest fee included three meals a day. The day's activities were posted in the lobby, and patrons could pick up their mail at the desk. Some guests arranged for long stays, and some stayed all season. The guest register and other artifacts are housed at the Northfield Historical Society Museum. The high ceilings and dark, varnished wood trim displayed the Victorian decorating style. The massive furniture was in contrast to the New England Colonial style of the Main Street homes and inns. Also note the gas lighting, as the town was not electrified until 1910. (Both, courtesy of NMH.)

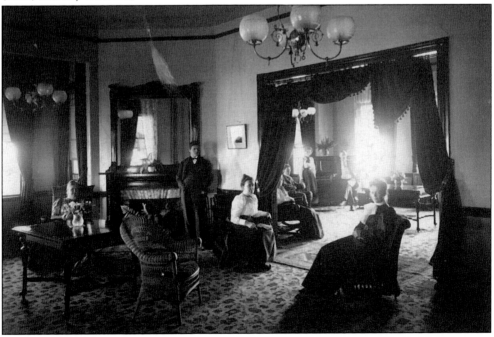

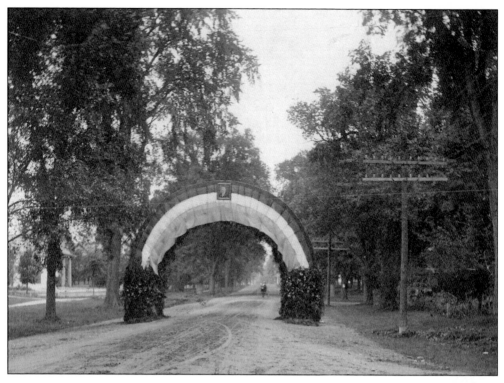

TEDDY ROOSEVELT, 1902. Over the years, famous people have visited the Northfield Hotel, but none more eminent than Pres. Theodore Roosevelt, who stayed overnight during a tour of New England in the late summer of 1902. Arriving by train at the Mount Hermon Station, he was driven to Mount Hermon School and spoke briefly at the chapel. A large crowd lined Main Street to welcome President Roosevelt as he proceeded to the hotel beneath a special archway created for his visit (above). After dinner, the president spoke to an audience of 3,000 at the Auditorium at the Northfield Seminary. Seen below in a stereoptic image, Roosevelt and his appear on the north portico of the hotel. (Above, courtesy of NHS; below, LOC.)

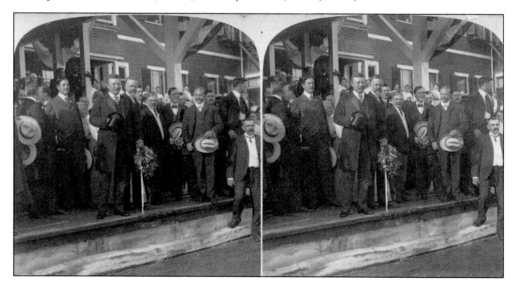

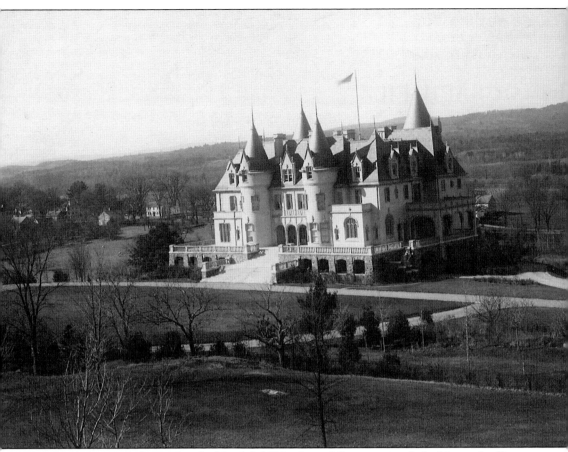

THE CHATEAU, 1913. Soon after the Northfield Hotel was fully operational, the biggest dwelling Northfield residents had ever seen, a chateau called Birnam House, was built on land adjacent to the hotel and golf course in 1902 for summer use by a wealthy New York capitalist and devoted Moody follower Francis Robert Schell and his wife. After Schell died in 1928, his widow gave the castle and grounds to the Northfield Schools. It became a summer annex to the Northfield Hotel for guests looking for a romantic experience. Its lower level became a youth hostel in the 1930s; Eleanor Roosevelt attended the dedication. The Chateau Tea Room was a popular place. The Northfield Schools used the chateau for its annual prom, called "the Chat." The chateau was razed in 1963, when the schools could not maintain it any longer. Today, the lake area is a wildlife sanctuary enjoyed by residents. (Courtesy of NMH.)

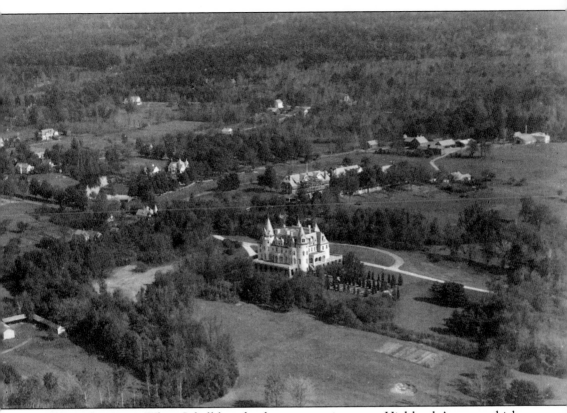

CHATEAU, 1930S. When Schell bought the property, it was on Highland Avenue, which ran from the Dwight L. Moody birthplace to Warwick Road (Avenue). He had several houses moved, and, not wanting his estate broken up and disturbed by a road, he paid the Town of Northfield $5,000 to close Highland Avenue at Holton Street. The town used Schell's payment to fund the building of Birnam Road. Today, the crescent created by the driveway is the site of a Northfield Golf Club putting green. From that spot, one can look up and imagine the amazing height of the castle and the view it provided. (Courtesy of E. Finch.)

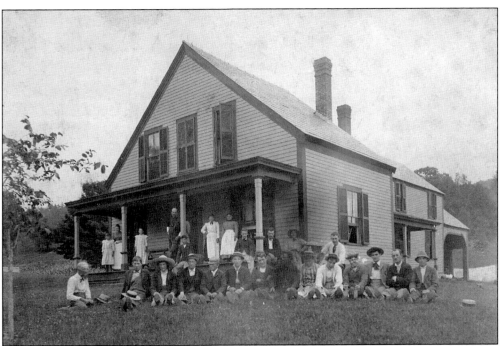

CHATEAU CRAFTSMEN.
Scores of builders, painters, landscapers, and stonecutters were brought to Northfield, some from foreign countries, to work on the Chateau, designed by Bruce Price, architect. It had 125 rooms, 3 bedrooms, 23 baths, and included a complete chapel, a ballroom, a double spiral staircase, circular rooms, huge fireplaces, and high terraces overlooking an Italian garden and a view of the Connecticut River Valley. The craftsmen lived communally in the neighborhood and were a spirited group. Some of the men worked on other buildings on the campus, as well. (Both, courtesy of NMH.)

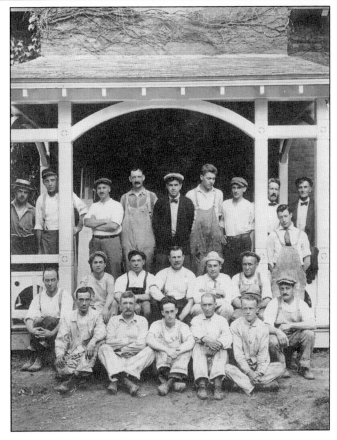

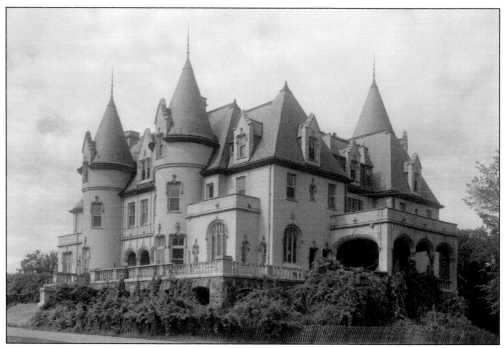

BIRNAM HOUSE. Francis Robert Schell named the Chateau after the beloved town of Birnam in Perthshire, Scotland, because the view from the west porch reminded him of the Scottish landscape. When it opened in June 1903, Birnam House had the appearance of a French chateau, but the interior was more like an English country house. For the townspeople, whose aesthetic sensitivities were nurtured among Stearns-built houses, the Chateau was quite a shock. In time, the community came to take great pride in having such a picturesque landmark, and many were dismayed when it was demolished in 1963. (Courtesy of LOC.)

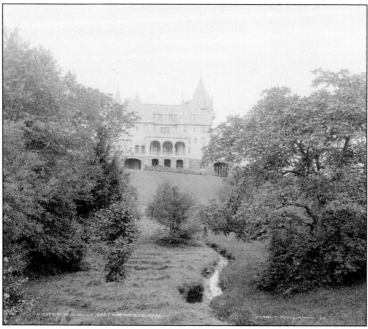

BIRNAM HOUSE TERRACE, 1914. Looking west from the terrace, Francis Robert Schell could view 125 acres of grounds that were meticulously landscaped and included a half-mile-long lake made by damming Warwick (also known later as Mill) Brook. Down this path, Schell and his guests walked to a dock and boat, kept for entertaining weekend visitors from New York. (Courtesy of LOC.)

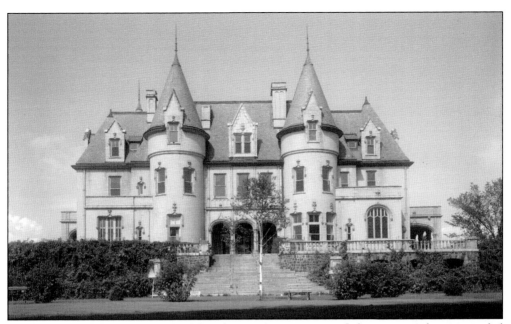

THE CHATEAU, EAST. On this side of the Chateau, 30 granite steps led to a terrace that surrounded the building, giving the guests a spectacular view of the valley. The twin towers flanked grand, three-arched entryways that opened into a huge main hall with glittering chandeliers. Until 1963, this was the site for the Chateau Dance, an elegant evening held in May for Northfield and Mount Hermon seniors. Although the Chateau is gone, "the Chat" is still the name given to Northfield Mount Hermon's senior prom. (Courtesy of LOC.)

THE NORTHFIELD INN AND CHATEAU. After a period of failing health, Francis Robert Schell died in 1928. His wife returned to Northfield each year, but stayed in the Northfield Hotel/Inn. Eventually, she sold the Chateau to the Northfield Hotel/Inn, and it became a much-sought-after place to stay for a romantic experience. In 1939, the ground-floor area was used as a youth hostel. (Courtesy of NHS.)

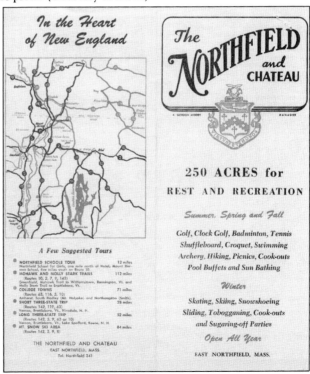

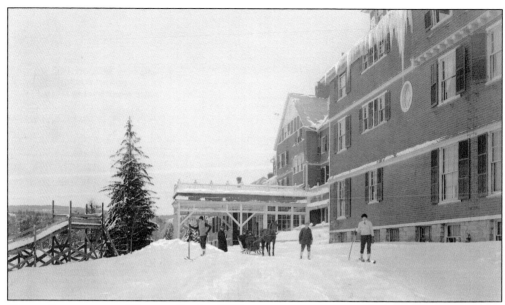

HOTEL ENTRANCE IN WINTER. In the 1920s, visitors spent winter holidays outdoors at the Northfield. Sleigh rides, skiing, skating, and tobogganing were popular. The winter activities were a welcome boost to tourism during the months when the hotel/inn had to be heated. The heating expense was an issue for years. (Courtesy of NMH.)

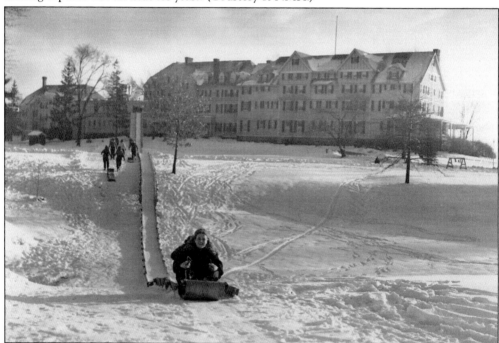

TOBOGGAN SLIDE. This contraption at the Northfield Hotel attracted daredevils from among the clientele and the groups of students from the Northfield Schools. Constructed of wood and two stories high, the slide was available only when there was plenty of snow on the ground. This hotel slide may have originated at Mount Hermon, where tobogganing was a winter sport in the 1920s. (Courtesy of B. Richardson.)

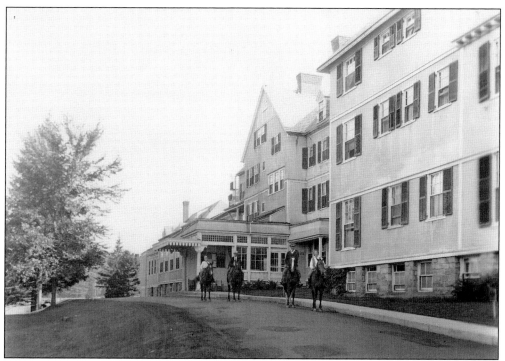

HORSEBACK RIDING. In the manner of an English country house, horses were boarded in the Carriage House for guests who liked to ride. The hotel maintained a stable of its own horses for both riding and working. Guests could ride on the Schell estate or on the miles of trails that traversed Strobridge Hill. (Courtesy of B. Richardson.)

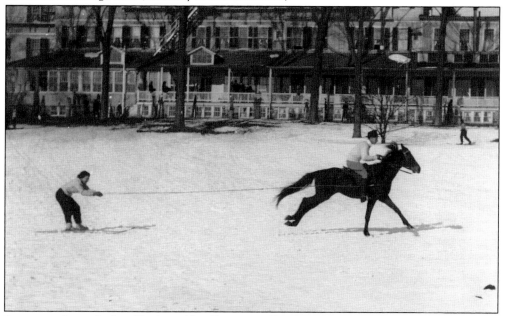

SKIJORING. Since the hotel had a stable of horses, it offered the spectacular winter sport of skijoring to its guests. Originally a means of winter travel in Scandinavia, skijoring became a demonstration sport in the 1928 Winter Olympics. (Courtesy of NMH.)

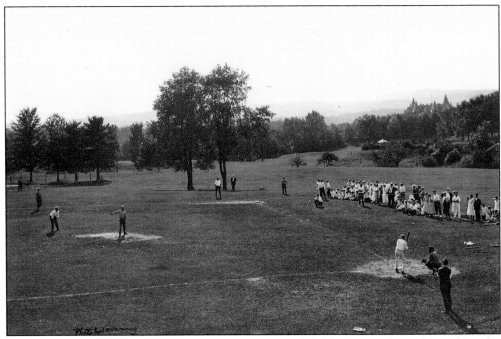

BASEBALL, 1921. On a diamond in the shadow of the Northfield Chateau, the traditional Sunday afternoon baseball game was popular with men and women alike. This field appears to be on land now part of the Northfield Golf Club. Perhaps this game is taking place on the golf course and there were no Sunday golfers in 1921. (Courtesy of NMH.)

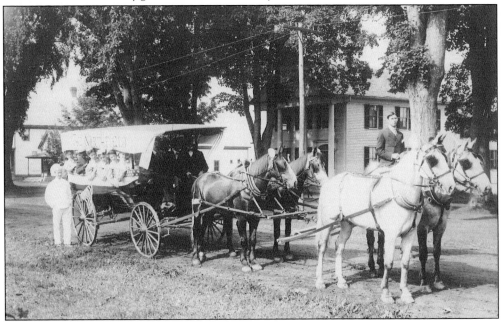

SHOPPING IN TOWN. This wagon had several important functions. As one of the daily activities, horses were hitched up for guests to make shopping visits to the Northfield village. Here, it almost appears that the wagon is part of a local parade. The Northfield Hotel made every effort to be a part of local activities, offering its grounds for pageants and celebrations. (Courtesy of NMH.)

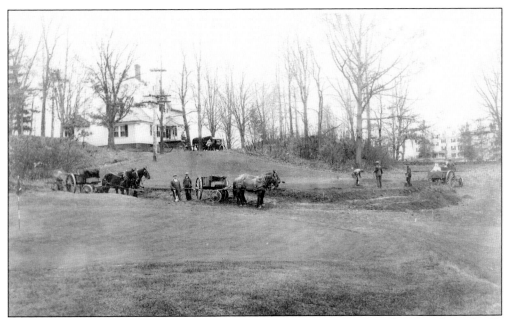

NORTHFIELD GOLF COURSE. In 1905, trustees recruited a golf-course architect, Alexander H. Findlay, to design a nine-hole layout for the enjoyment of the hotel guests. Findlay, known as the Father of American Golf and the designer of some of the best-known golf courses in America, surrounded the hotel with 2,760 yards of fairways and greens. In the above photograph, builders use horses and wagons to construct the seventh hole, one of the two water holes on the course. The course opened in 1912 and proved to be challenging, interesting, and fun. Below, a mixed group of 1950s golfers prepare to hit off the sixth tee just below the hotel. Although the hotel was demolished in 1977, this course continues to operate under private ownership and maintains an active membership. (Both, courtesy of NMH.)

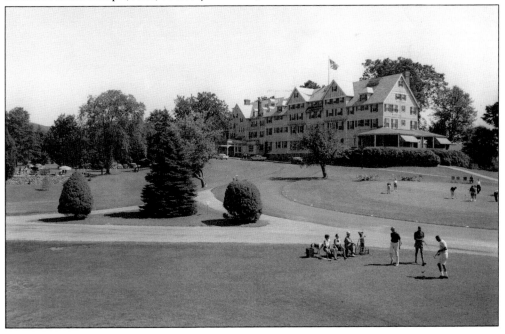

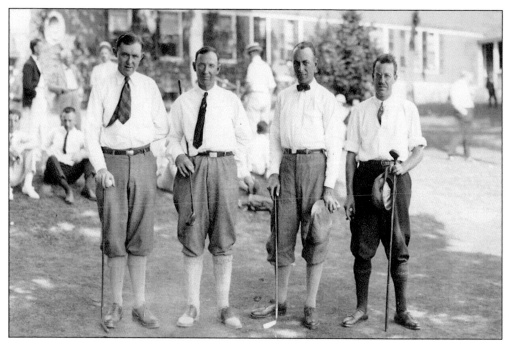

NORTHFIELD FOURBALL MATCH, 1920S. Dressed in fashionable golf attire (tweed knickers, white shirts, and ties) and holding their favored hickory-shafted woods or putters, these golfers have just finished their round at the Northfield Inn Golf Club. The hotel held many of these friendly tournaments, which led to lasting friendships and memories. (Courtesy of NMH.)

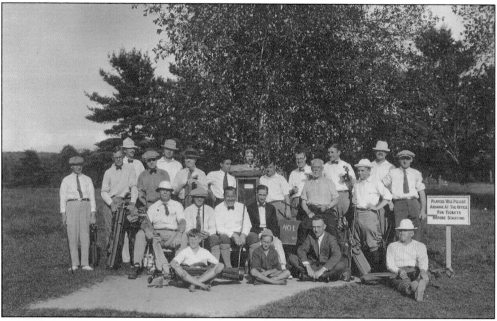

NORTHFIELD GOLF TOURNAMENT, 1922. About to tee off on the first hole, this group of men gathers for a photograph to mark the occasion. Note that half of the players wear ties, and half have already pulled them off. Note the barefoot caddies. Leagues have always kept the Northfield Golf Club busy. (Courtesy of NMH.)

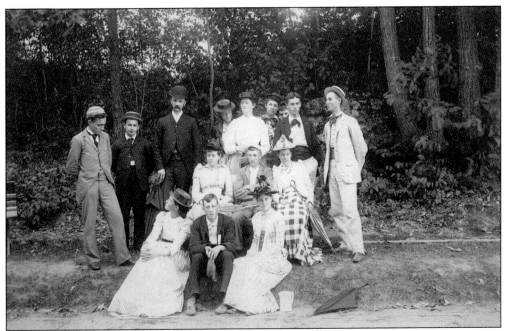

TENNIS, 1890. Photographed near the Northfield Hotel tennis courts, this group of men and women, smartly dressed and completely covered from head to toe, would not be released from such sartorial convention until the 1920s. They present a dramatic contrast to today's tennis crowds, who dress in spandex, sunglasses, and T-shirts. (Courtesy of NMH.)

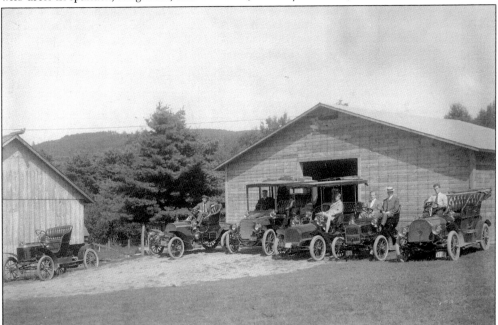

THE HOTEL GARAGE, 1912. As automobiles became popular, the hotel maintained a "stable" of touring cars for the pleasure of its guests wanting to see a bit of New England. The garage also housed utilitarian vehicles to be used by the hotel staff. In 1912, the nearby Carriage House would have still been an active facility for storing carriages and stabling horses. (Courtesy of NMH.)

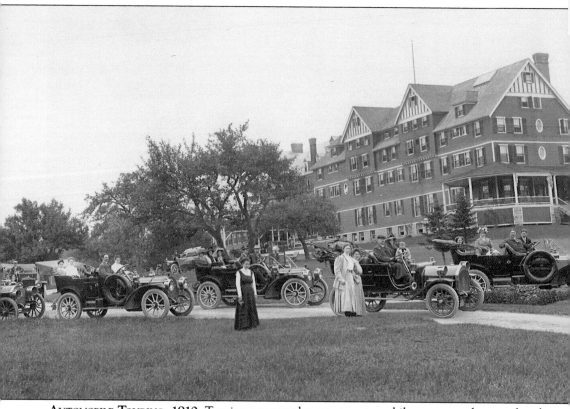

AUTOMOBILE TOURING, 1910. Touring was popular among automobile owners and among hotel guests from the city. Touring cars had open-air seating for four or more passengers. The "fan cover" could be raised to protect passengers from wind and rain. The cars in the photograph are, from left to right, three Packards, a Northern, a White Steamer, and a Locomobile Model I. (Courtesy of NMH.)

DINING ROOM, 1928. The hotel offered a fine dining experience for its visitors. Over the years, many Northfield residents worked in the kitchen or waited tables in the dining room. In the summer, college students worked as waitresses, bus boys, and dishwashers. The dining room (above) featured a traditional New England menu and became a favorite destination for Sunday dinner as well as for holidays like Thanksgiving and Easter. The porch (below) off the main dining room, offered a quieter and more intimate dining experience. It looked out on the golf course. Facing south, it captured the morning and afternoon sun. (Above, courtesy of NMH; below, B. Richardson.)

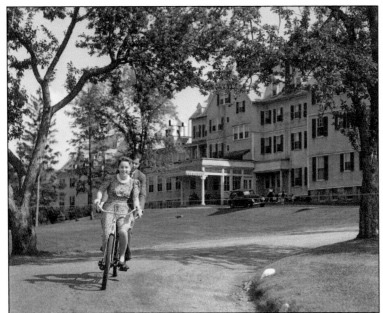

A Bicycle Built for Two, 1944. Many young couples chose the Northfield Hotel/Inn for their honeymoons. This couple has borrowed the hotel's tandem bike for a spin around East Northfield. (Courtesy of NMH.)

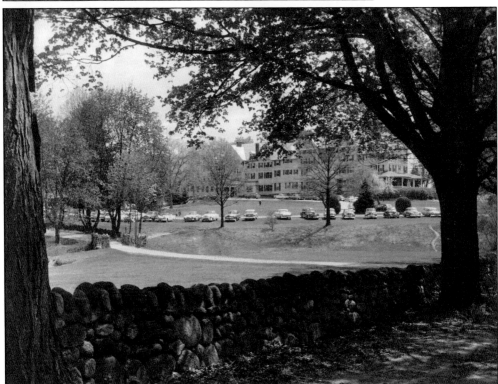

Holiday Dinner at "the Inn." The Northfield Hotel/Inn was the place to go for a family special occasion. The menu was elegant and priced reasonably for a family table. One could always count on seeing friends here, and strolling the grounds afterward was allowed. Many people have said that what they miss most is the dining room, decorated for fall foliage season, Christmas, and Easter. The cars shown here would no doubt be valuable to collectors today. (Courtesy of NMH.)

Nine

DISASTERS
COMMUNITY RESILIENCE

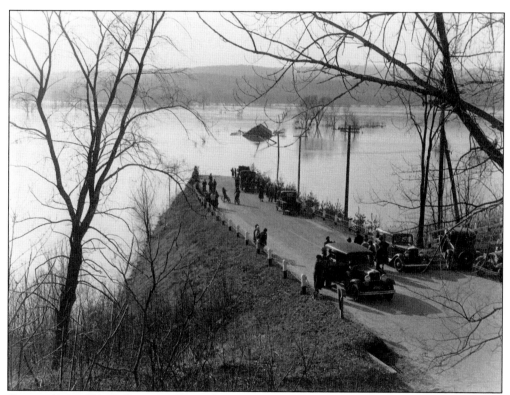

CONNECTICUT RIVER FLOOD, 1936. The Connecticut River's spring waters annually flooded Northfield fields, leaving rich soil for farming. The river provided a quiet and peaceful presence in Northfield throughout the summer and fall; however, it violently topped its banks and inundated fields, homes, barns, and roads in 1927 and again in 1936. Northfield residents lost crops, property, farm animals, and cars, and the community lost bridges. In its long history, Northfield has often endured the hardship of tragedy and loss. With indomitable community spirit, whenever disaster struck, Northfield citizens summoned the strength to restore and rebuild. (Courtesy of NHS.)

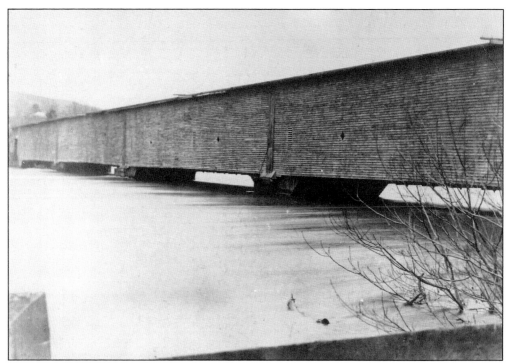

FLOOD OF 1936. Northfield had fresh memories of the flood of 1927 when, in March 1936, heavy rains and warm weather created a rising, raging river full of giant ice floes. Vernon Dam broke, resulting in vast destruction downstream in Northfield. The town's railroad bridge was destroyed. (Courtesy of NHS.)

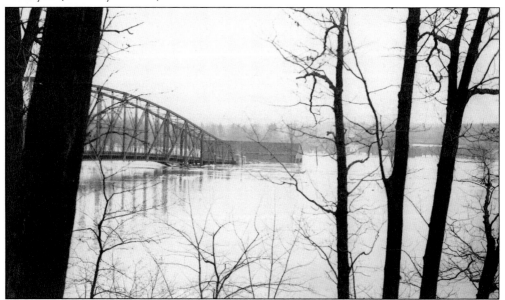

SCHELL BRIDGE, 1936. The Schell Bridge, a steel-truss span built in 1903, was submerged but held its ground. Likewise, the Bennett Meadow Bridge survived. Ice, carried by the swollen river, struck bridges and piers, crashing and banging like thunder. The sounds could be heard a mile from the Connecticut River, on both sides of the water. (Courtesy of Dickinson Memorial Library.)

SCHELL BRIDGE, LOOKING WEST, 1936. On the west side of Schell Bridge, the river cut a new channel and surrounded the farms in West Northfield and into Vernon. Almost 1,000 feet of highway was washed away on the west bank. All sorts of things were seen being carried down the river, including a kerosene stove, parts of vehicles, furniture, and animals. (Courtesy of NHS.)

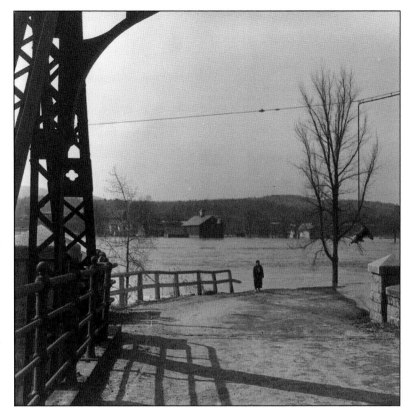

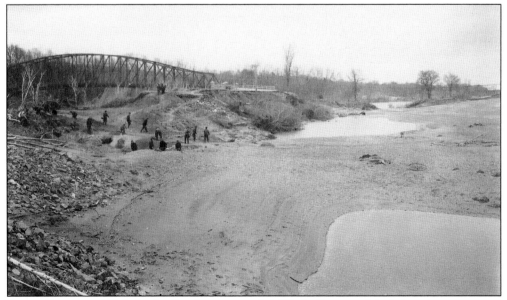

FLOOD CLEANUP, 1936. As the floodwaters receded, Works Progress Administration crews were brought in to help clear the destruction on the west side of Schell Bridge, where huge volumes of soil were scooped out of the fields. Suspended in the floodwaters, the soil was transported downstream. The flood left broad gullies and ruined fields that would never again see tobacco farming. (Courtesy of NHS.)

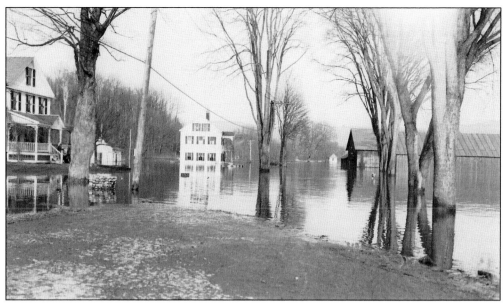

NORTHFIELD/BERNARDSTON ROAD, 1936. In Bennett Meadow, the homes and tobacco barns were threatened, but they received protection from King Philip's Hill, which sheltered these homes from the fury of the flood. On the east side of the river, Great Meadow was a lake stretching all the way to Main Street. There was no way to get out of Northfield, and people survived on preserved food stored the previous summer. (Courtesy of NHS.)

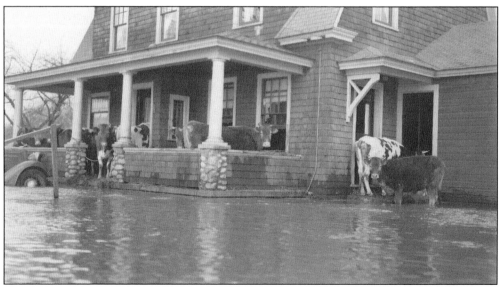

ZABKO FARM, 1936. At the Zabko home, terrified cattle took refuge on the porch. The Red Cross set up a temporary shelter at the No. 4 Schoolhouse for about 60 people who lived on Lower Farms Road. There, they were fed and housed. (Courtesy of Dickinson Memorial Library.)

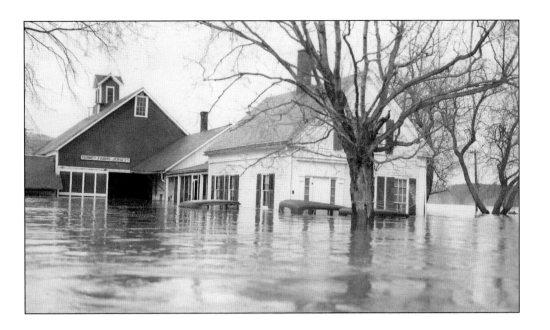

TENNEY FARM, 1936. At the Tenney Farm, all but two of the 350 head of cattle were drowned. When the water began to rise, the panicky herd stood in the rising waters and refused to move to higher ground. One cow, a mother in labor, found a loft. She and her newborn calf were the only survivors of the herd. An eerie silence remained after so many cattle had lost their lives. At the Zabko home nearby, three terrified cattle were found on a porch. The dead cattle were buried in deep trenches in the silt-covered meadow. (Both, courtesy of NHS.)

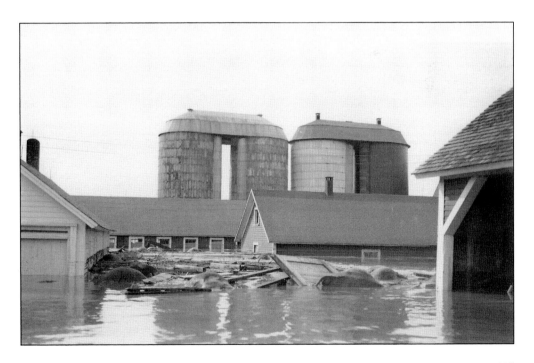

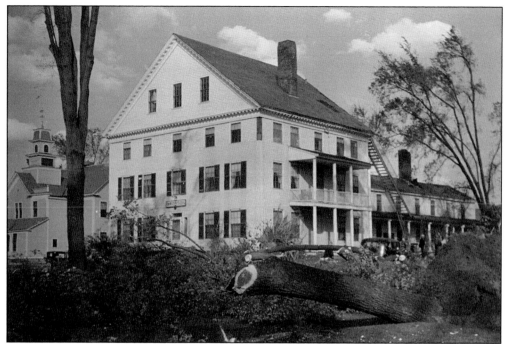

HURRICANE OF 1938. A half-century after the Great New England Hurricane of 1938, one could walk into the woods in Northfield and still see the stumps of the trees that were felled by the 115-mph winds. By the time the hurricane arrived in Northfield, the ground was so soaked by four days of rain that the winds just pushed over the white pines. For three hours on the afternoon of September 21, 1938, the hurricane winds blew, bending trees until they snapped, stripping leaves from every deciduous tree and pine, and uprooting some of the oldest and tallest trees so that the entire root system was exposed. When it was all over, the town was isolated for days; electric and telephone wires were hanging everywhere. On Main Street, the rows of maple and elm trees that had graced the town common for more than 100 years were ravaged by the wind, and 50 percent of the trees were uprooted. (Both, courtesy of NHS.)

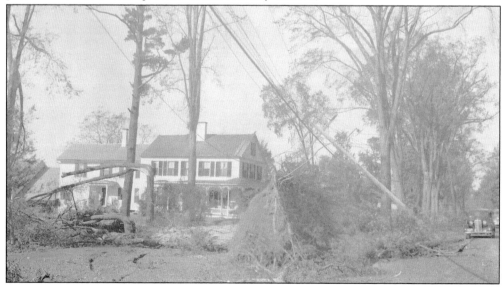

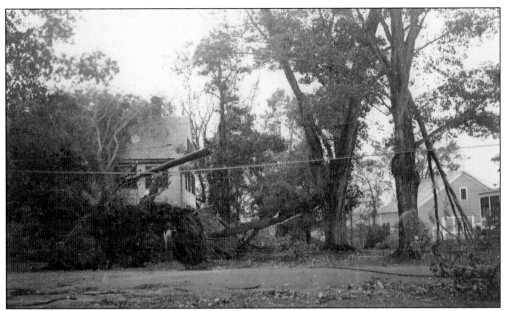

MAIN STREET DAMAGE, 1938. This photograph shows the aftermath of the hurricane on the corner of Main and Meadow Streets. Half of the maples and elms along Main Street were uprooted. These huge trees, planted in the early 1800s during a beautification project, were never replaced. Northfield's Main Street, with the four rows of towering trees alongside it, became part of its history. (Courtesy of Dickinson Memorial Library.)

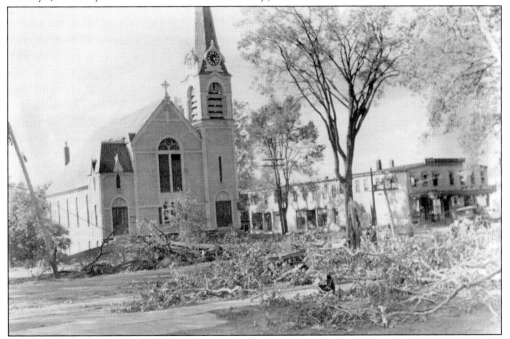

TOWN CENTER, 1938. The First Parish, built in 1871, escaped significant damage. Trees were lost, and telephone and electric lines were felled, hindering communication. Trucks went into the streets to clear debris. As with the 1936 flood, Civilian Conservation Corps crews from Warwick provided a lot of manpower to open the roads. (Courtesy of NHS.)

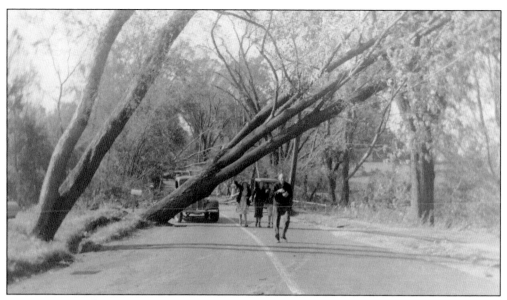

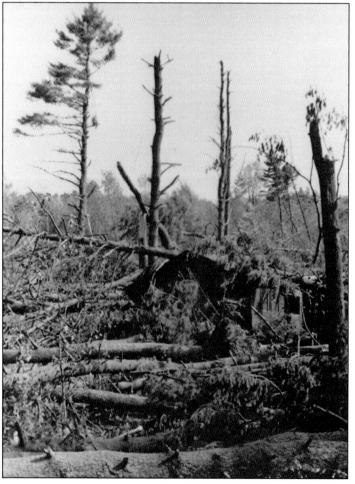

NORTHFIELD INN HURRICANE DAMAGE. Inn visitors who expected to enjoy the fall foliage discovered a minefield of fallen trees on their excursions to survey the damage in the vicinity of the Northfield Inn. (Courtesy of NHS.)

RUSTIC RIDGE, 1938. On the hillside in East Northfield, this cottage, called House in the Pines, was nearly obliterated by falling white pine trees. The lone pine left standing shows how the landscape was remade in just a few hours. (Courtesy of Dickinson Memorial Library.)

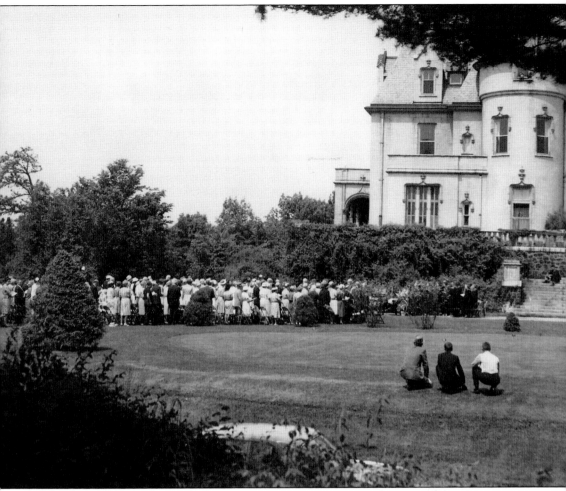

FINAL CHURCH SERVICE AT THE CHATEAU, SUMMER 1963. Parishioners of the Trinitarian Congregational Church of Northfield attended their last service held each summer at the Chateau, which was slated to be demolished in the fall of 1963. Trustees of the Northfield Schools made the wrenching decision to demolish the Chateau. An extensive engineering assessment determined that work to be performed to make it a safe building would be more expensive than the Northfield Schools could afford. (Courtesy of E. Finch.)

CHATEAU AUCTION, 1963. On July 26 and 27, 1963, the entire contents of the Northfield Chateau were sold at public auction, pictured left, by Ken Miller and Son, local auctioneers. The 917 items auctioned were all furniture and fixtures, paintings, mirrors, sculpture, mantles, rugs, chandeliers, an organ, and stained-glass windows. The marble fireplace mantle and mirror shown below went to Belcourt Castle in Newport, Rhode Island. All of the furnishings were auctioned before the Chateau was razed in 1963. (Left, courtesy of B. Richardson; below, LOC.)

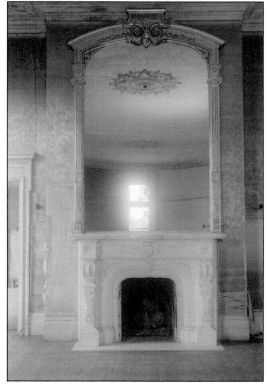

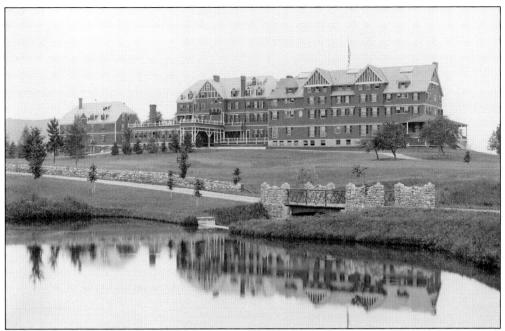

An Aging Hotel. After the Chateau was demolished, it was hoped that the hotel could be sold to an enterprise better equipped to manage the much-needed renovation of its exterior and interior, including the heating, electricity, and plumbing. In the 1970s, the inn, which had once been a grand and beautiful resort in the early 20th century, had become a tired old building during decades of inflation, unemployment, and energy shortages. The land on which the inn stood had value, and the golf course was used in the school's athletic program. It was primarily the hotel that was siphoning off money that could be used for the schools' educational programs. (Above, courtesy of LOC; below, NMH.)

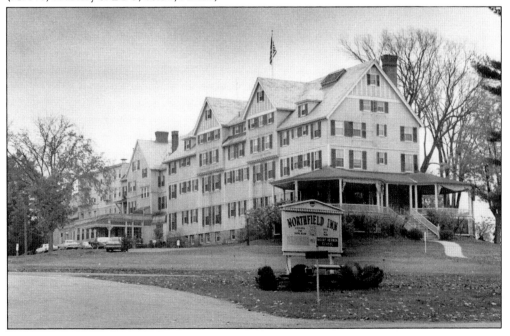

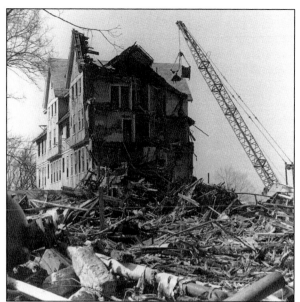

Hotel Demolition, 1977. In 1976, the Northfield Mount Hermon Trustees voted to demolish the Northfield Hotel/Inn. Although the inn had a long run as an attractive destination resort, it fell victim to gradual socioeconomic changes that made it less of an asset. It was very expensive to heat and in dire need of renovation. The impact of its closing was felt by the families who relied upon the hotel for employment. However, Northfield residents and summer vacationers continue to enjoy its recreational assets, such as the pool and golf course. (Courtesy of NMH.)

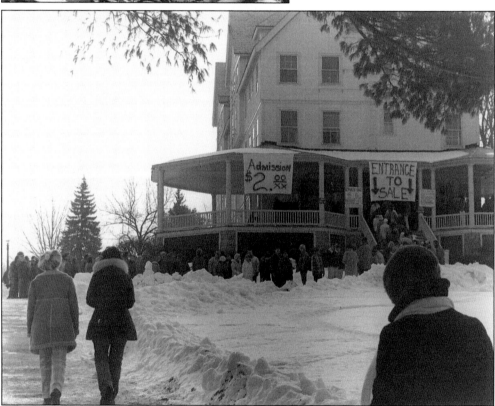

Hotel Tag Sale, 1977. Before the inn was demolished in April 1977, all of its furnishings, china, silverware, bedding, rugs, curtains, and photographs were sold. A mammoth, two-day tag sale was mounted in early 1977. Long lines snaked down the walkway as people waited to get into the hotel. Some were hunting for bargains, but most were just looking for an object or two that would hold their memories of this once-grand hotel. (Courtesy of NMH.)

112

TRINITARIAN CONGREGATIONAL CHURCH, 1978. On January 21, 1978, one of Northfield's significant buildings burned to the ground. Trinitarian Congregational Church was built in 1889. Dwight L. Moody preached to a full congregation there many times. It was a sad Sunday morning for the town of Northfield. The firefighters worked tirelessly to save the structure, and several were injured from a backdraft. Northfield Mount Hermon School offered Sage Chapel as a place of worship until the building was replaced in late 1979. (Courtesy of Northfield Fire Department.)

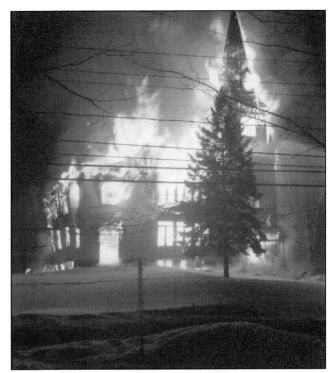

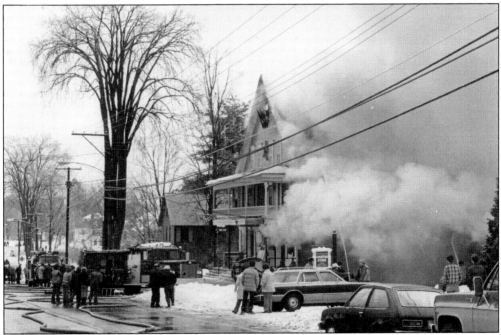

NEW ENGLAND COUNTRY STORE, 1978. Also in 1978, the New England Country Store was destroyed by fire. This was a major loss to those in East Northfield who walked to the store for groceries and meat. Because the national economy was so weak, the owners of the store were unable to rebuild. The site remained empty until a group of businesses were established in a new building in the 1980s. (Courtesy of Northfield Fire Department.)

NORTHFIELD CAMPUS CLOSES, 2005. In 2004, the trustees of Northfield Mount Hermon Schools, which had merged in 1971, decided to close the Northfield campus and consolidate the educational program at the Mount Hermon campus (shown here). In 2009, the Northfield campus was sold. Its owners have struggled to find a new school to occupy its historic buildings. The seminary campus, which had for more than 100 years been a significant engine in the town's economy, could, someday, once again be a vital part of Northfield. (Courtesy of LOC.)

Ten

RECREATION
EXPERIENCING SERENITY AND BEAUTY

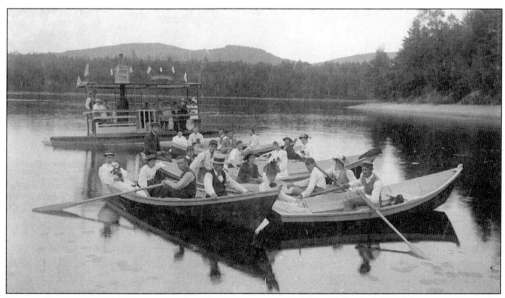

RIVER PARTY, 1889. The recreational resources available to Northfield visitors, such as the river, the lakes, and the trails, provided memorable outdoor experiences. Year after year, these memories beckoned families back to the Northfield Hotel, the Northfield conferences, and the Rustic Ridge communities. Today, these assets attract visitors and year-round residents who want to raise families in a beautiful environment. This inventive family has rigged a wooden boat with power. They are courting young women on the Connecticut River. (Courtesy of NMH.)

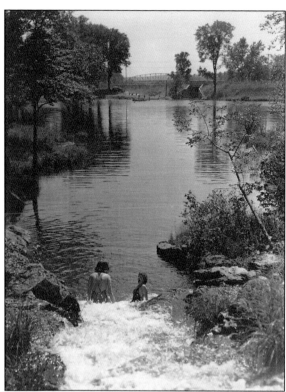

WANAMAKER LAKE AND FALLS, 1930s. A dam on Pauchaug Brook created Wanamaker Lake. Here, two girls sit at the base of Wanamaker Falls, which empties into Wanamaker Lake. Schell Bridge can be seen in the distance. The dam is below the small concrete bridge. Today, Pauchaug Brook runs quietly through the lake bottom, which is filled with Japanese knotweed and other invasive plants. These children are now town elders who reminisce about Wanamaker Lake. (Courtesy of E. Finch.)

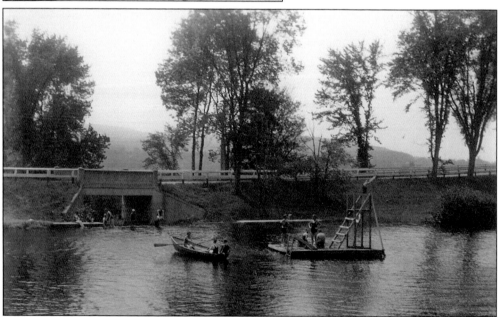

WANAMAKER LAKE, 1928. Children often walked a mile or two to Wanamaker Lake, and the Northfield Hotel transported its guests here. The road seen here leads to Hinsdale, New Hampshire. Children playing on the dam beneath the bridge have rigged up a diving board on the dam. Three girls are in the rowboat. The raft has a ladder, a diving board, and a diving platform. A dog paddles in the foreground. Such memories of summer last a lifetime! (Courtesy of NMH.)

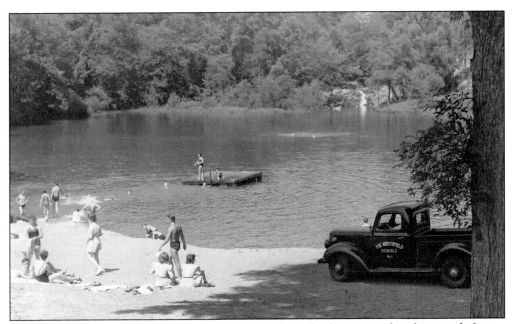

WANAMAKER LAKE, 1930s. Wanamaker Falls is visible in the distance in this photograph. In just a few years, the new beach had become the attraction—or, perhaps, the lifeguard had. The raft has lost its diving apparatus, but this lake, within walking distance of most of East Northfield, is the place to be on a hot summer day. (Courtesy of E. Finch.)

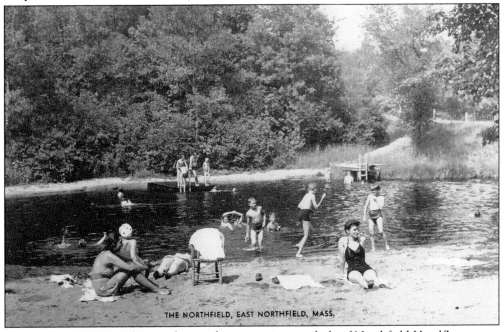

THE NORTHFIELD, EAST NORTHFIELD, MASS.

SCHELL POOL, 1940s. This pond was a favorite swimming hole of Northfield Hotel/Inn guests and neighborhood families. Long after the big dam for Francis Robert Schell's lake was breached, a smaller dam was built on the Warwick/Mill Brook, which winds through the Schell estate, to create a place to swim and fish. The inn provided lifeguards and sand for the beach. Schell Pool was around until the early 1970s. (Courtesy of E. Finch.)

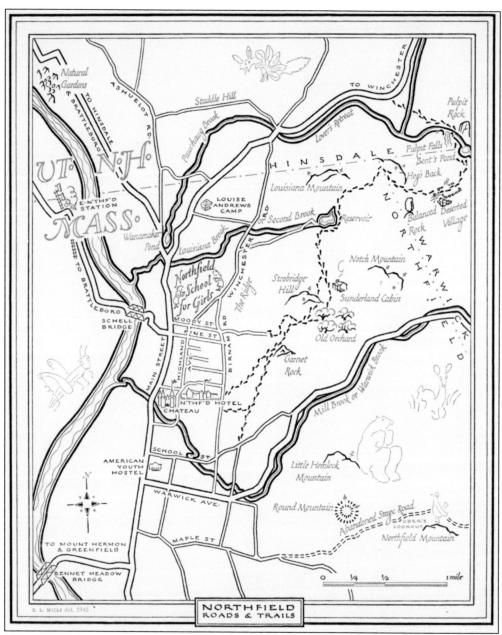

NORTHFIELD SEMINARY TRAILS. The hillside above the Northfield Inn and the seminary was popular with hotel guests, seminary students, and residents of East Northfield. In the early decades of the 20th century, much of the terrain was barren of trees. Outcroppings of rock attracted hikers seeking a view. Garnet Rock, Notch Mountain, Strobridge Hill, and Louisiana Mountain were favorite destinations. The area today continues as a managed forest. Northfield mountain trails are still popular for hiking, snowshoeing, and cross-country skiing. (Courtesy of J. Stoia.)

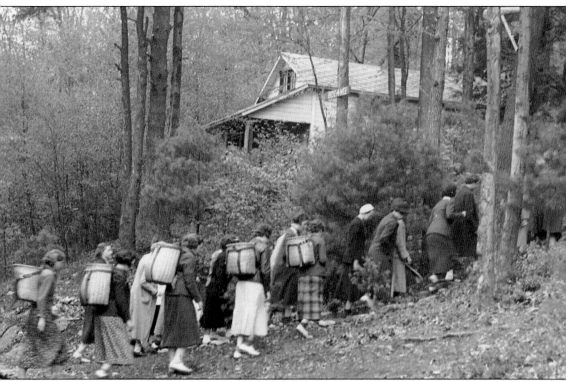

HIKING TO SUNDERLAND CABIN. Northfield Seminary maintained Sunderland Cabin for overnight use by students. These girls, outfitted with basket packs, head up the hill to the cabin. Unfortunately, because it was isolated, Sunderland Cabin fell victim to vandals and was destroyed by fire in the 1970s. It was just below the top of Strobridge Hill and not far from the trail up Notch Mountain. (Courtesy of NMH.)

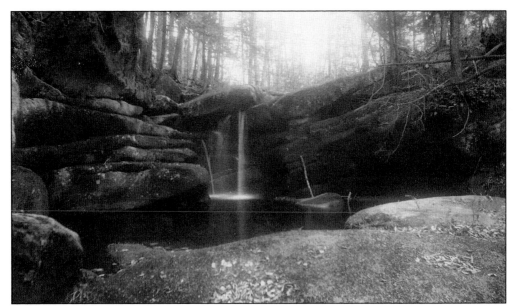

PULPIT ROCK AND FALLS. This longtime swimming destination requires a hike to get to, but upon arrival, its cool waters provide relief on a hot summer's day. This early photograph of Pulpit Rock shows a large rock formation in the bed of Pauchaug Brook. To get there, one must hike over Louisiana Mountain, past the reservoir, and then down into the ravine to the brook. Alternatively, one could follow the road to Lover's Retreat off Winchester Road. With the music of falling water, it is a unique swimming experience. (Courtesy of NMH.)

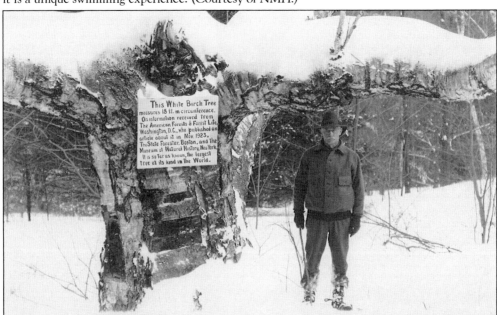

LARGEST BIRCH TREE IN THE WORLD. This tree could be seen on the trail beyond the reservoir, not far from Pivot Rock (an enormous glacial boulder). Its circumference was 18 feet, and it was 80 feet tall. Unfortunately, it was destroyed by fire, so this early-20th-century photograph is all that is left. Maps indicate a location called Birch Point, which might be the site for this amazing tree from Northfield's history. (Courtesy of NMH.)

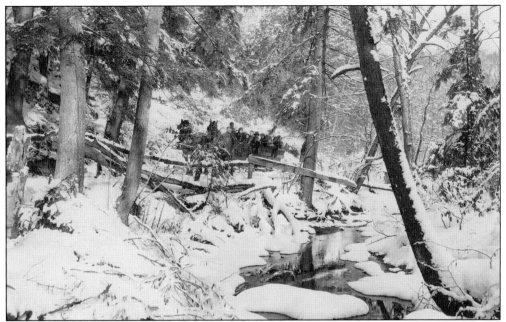

WINTER SLEIGH RIDE. When snow fell, it was time to put away the wagons and get out the sleighs, which made it possible to perform farm chores on hard-packed snow. These women are out for a winter sleigh ride, probably on the carriage road that climbs Strobridge Hill. This road has short side trails that lead to points of geologic and historic interest, including Garnet Rock and several cellar holes. (Courtesy of B. Richardson.)

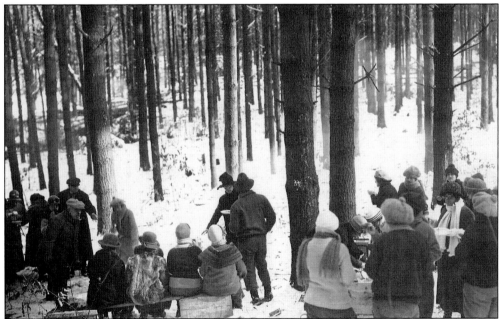

WINTER PICNIC. The Northfield Hotel's guests were entertained by novel experiences, such as winter campfire picnics. If a guest wanted lunch, they had to show up, even if all they had to keep warm was a raccoon coat or a mink stole. Everyone looks pretty chic in their fashionable 1920s felt hats and berets. (Courtesy of NMH.)

SNOWSHOE PARTY. The miles of trails on Strobridge Hill and Notch Mountain used by hikers in the summer revealed a winter wonderland after a fresh snowfall. Here, a party of 10 crosses Birnam Road. They will head up the hill for a snowshoe expedition. (Courtesy of NMH.)

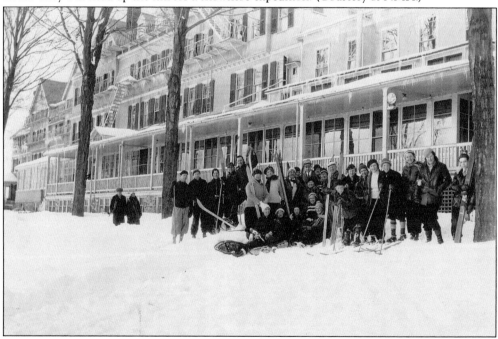

SKI PARTY. Skiers and snowshoers pose for a group photograph outside the Northfield Hotel/Inn before a day of winter activity. In the early days, skiers used the golf course's rope tow. If that was too tame, skiers would put on ski-skins and climb a hill—an exhausting experience. The trips downhill made it all worthwhile. (Courtesy of B. Richardson.)

BIRNAM ROAD SKI HILL. As it became evident that skiers wanted more of a thrill than the golf course could provide, the Northfield Hotel/Inn developed a steeper ski hill on Birnam Road, with a longer rope tow run by an old Chevy engine. After the rope had pulled the skiers up the hill, it only took a minute or two to get to the bottom, but it was a great "learning" hill. Northfield residents enjoyed the nearby slope, practicing on it before heading to the Vermont mountains. From the carriage road, one can spot the remains of the rope tow at the top of the hill, although it has been closed since the early 1970s. (Courtesy of B. Richardson.)

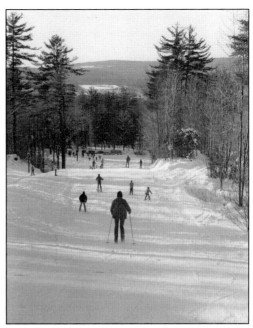

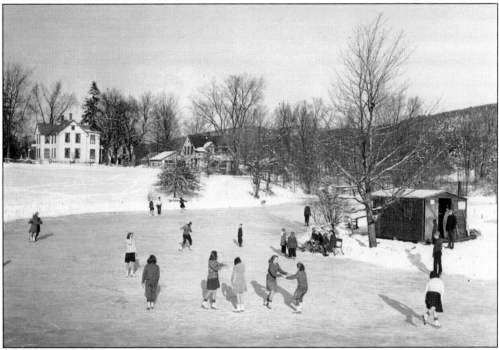

HOTEL SKATING. Skating was a popular pastime in winter. The Northfield Hotel/Inn kept Dickerson Pond in good condition. This made it possible for guests and local residents to enjoy cold winter days. Figure skating was popular, and there was often an informal hockey game at the east end of the pond. A warming hut was available for putting on skates, and hot cocoa was often available. One afternoon, the hut pictured here started to lean. As everyone jumped out,, the hut collapsed. It was replaced with a bigger warming space with a fireplace. It has since been removed. (Courtesy of NMH.)

HOTEL NATURE TRAIL. This trail began near the first tee on the golf course and led downhill toward the Schell property. Guests could consult a brochure that provided identification of local flora and fauna. Years later, a class at Northfield Mount Hermon School designed a different nature trail around the former Schell Lake. This area is filled with songbirds and waterbirds during their migrations. (Courtesy of NMH.)

HOSTEL FOUNDERS. In 1934, Isabel and Monroe Smith founded the American Youth Hostel (AYH) movement. They opened a hostel in 1935 at Schell Castle. Based on a model they observed in Germany prior to World War II, the Smiths established youth hostelling as an antidote to the poor quality of life experienced by young people in America's crowded cities. Through their efforts, hundreds of youngsters arrived in Northfield each summer with their bicycles and backpacks, headed off to explore northern New England and swelling the ranks of rail passengers using the East Northfield Station. (Courtesy of LOC.)

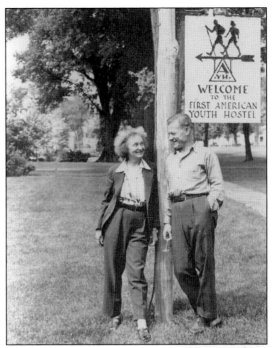

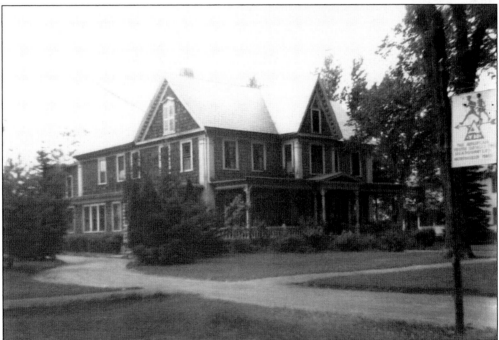

FIRST AMERICAN YOUTH HOSTEL. In 1939, AYH purchased this Main Street home, once owned by 19th-century composer Timothy Swan and his wife. Thousands of college-age AYH members traveled by bike through Northfield and stayed overnight here. After the building was sold, a controversial commune, Brotherhood of the Spirit, resided here in the 1970s when this photograph was taken. The structure, located at 88 Main Street, was destroyed by fire and replaced by a senior housing complex, Squakheag Village. (Courtesy of LOC.)

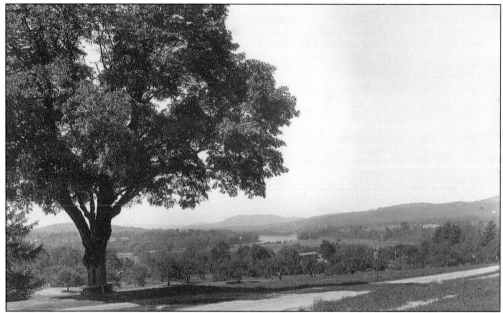

SUNSET TREE. This beautiful tree stood just north of Revell Hall and across the road from the Moody Homestead, at a point on Pauchaug Hill that presented a dramatic view of the Connecticut River and the northern valley. A.P. Fitt described it in *All About Northfield*: "Standing by Sentinel Tree one can drink in a scene that combines woods and water, hills and valley in a harmonious whole that is almost unequaled anywhere else—a rare New England landscape." Or, as Janet Mabie said years later in her book of the same title, it was "Heaven on Earth." (Courtesy of NMH.)

ROUND TOP, 1900. Many visitors and residents visit Round Top, a high point on the Northfield campus that still affords a scenic view of the river and mountains to the north and east. It is a place of remembrance and inspiration, of things past and things yet to come. It is not unusual to find someone in prayer at this sacred space. (Courtesy of LOC.)

BIBLIOGRAPHY

250 Years of Northfield, 1673–1923. Northfield, MA: Town of Northfield, June 22–24, 1923.

Carter, Burnham. *So Much To Learn, The History of Northfield Mount Hermon School for the One Hundredth Anniversary.* Northfield, MA: Northfield Mount Hermon School, 1976.

Congdon, Elizabeth. "A Paper on General John Nevers." Presented to the Northfield Historical Society at the Centennial House, 2006.

Fitt, A.P. *All About Northfield.* Northfield, MA: Northfield Press, 1910.

Garrison, J. Ritchie. *Landscape and Material Life in Franklin County, 1770–1860.* Knoxville: The University of Tennessee Press, 1991.

Garrison, J. Ritchie. *Two Carpenters: Architecture and Building in Early New England, 1799–1859.* Knoxville: The University of Tennessee Press, 2006.

Hamilton, Sally Atwood, ed. *Lift Thine Eyes: The Landscape, the Buildings, the Heritage of Northfield Mount Hermon School.* Northfield, MA: Northfield Mount Hermon School, 2010.

Mitchell, Ann Maria. "Old Days and New in Northfield," *New England* 16 (March–August 1897): 671–689.

Moody, William. *The Life of Dwight L. Moody by His Son.* Fleming H. Revell, 1900.

———. "Northfield 300th Anniversary" [Special Section] *Greenfield Recorder,* May 25, 1973.

Parsons, Herbert C. *A Puritan Outpost: A History of the Town and People of Northfield.* Macmillan, 1937.

Pollen, Dorothy C., ed. *Rivertown Review, Northfield, Massachusetts 1923–1973.* The Tercentenary Committee, 1973.

Sammartino, Claudia F. *The Northfield Mountain Interpreter: Facts About the Mountain, the River, and the People.* Berlin, CT: Northeast Utilities, 1981.

Stearns, Larry. *Bank to Bank: Ferry Boats of Northfield and Gill.* Northfield, MA: Northfield.

Temple, J.H., and George Sheldon. *History of the Town of Northfield, Massachusetts for 150 Years, with an Account of the Prior Occupation of the Territory by the Squakheags and with Family Genealogies.* Joel Munsell, 1875.

Tillson-Griffin, Shauna, comp. *Chateau.* Self-published in Northfield, MA.

———, comp. *Chateau 1903–1963.* Book Two. Self-published in Northfield, MA.

———, comp. *#95 RR Bridge through the Years.* Self-published in Northfield, MA.

———, comp. *The Northfield 1888–1977.* Self-published in Northfield, MA.

DISCOVER THOUSANDS OF LOCAL HISTORY BOOKS FEATURING MILLIONS OF VINTAGE IMAGES

Arcadia Publishing, the leading local history publisher in the United States, is committed to making history accessible and meaningful through publishing books that celebrate and preserve the heritage of America's people and places.

Find more books like this at
www.arcadiapublishing.com

Search for your hometown history, your old stomping grounds, and even your favorite sports team.